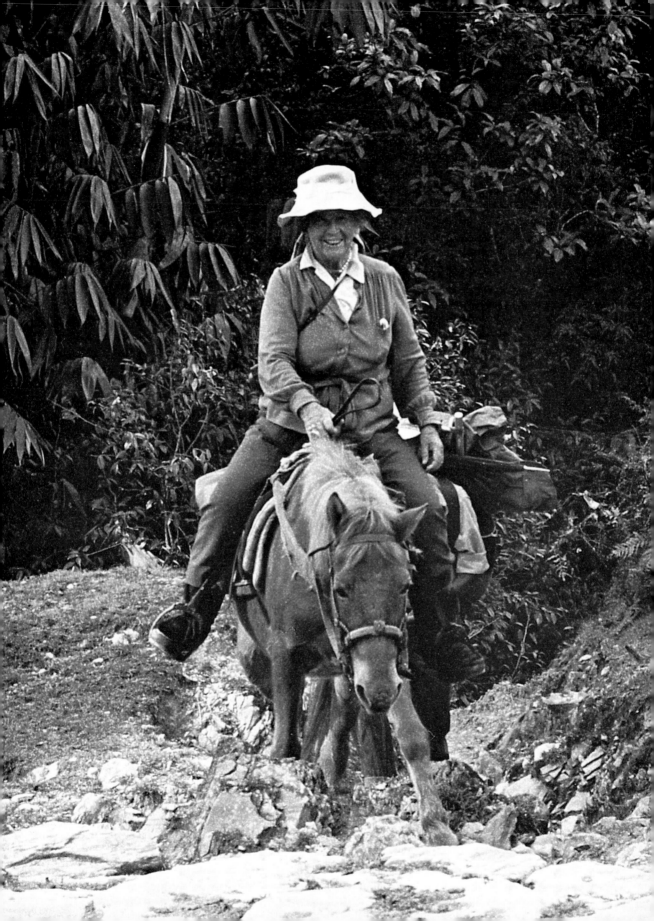

TRAVELLER THROUGH TIME

A Photographic Journey
with Freya Stark

MALISE RUTHVEN

VIKING

VIKING

Penguin Books Ltd, Harmondsworth, Middlesex, England
Viking Penguin Inc., 40 West 23rd Street, New York, New York 10010, U.S.A.
Penguin Books Australia Ltd, Ringwood, Victoria, Australia
Penguin Books Canada Ltd, 2801 John Street, Markham, Ontario, Canada L3R 1B4
Penguin Books (N.Z.) Ltd, 182-190 Wairau Road, Auckland 10, New Zealand

First published 1986

Designed by Yvonne Dedman

Typeset in Monophoto Ehrhardt
by Butler & Tanner Limited, Frome and London
Printed in Great Britain by
Butler & Tanner Limited, Frome and London

British Library Cataloguing in Publication Data

Ruthven, Malise
Traveller through time: a photographic journey with Freya Stark.
1. Stark, Freya 2. Orientalists——
Biography
I. Title
910.4′092′4 DS61.7.S83

ISBN 0-670-80183-6

Library of Congress Catalog Card Number: 85.052051

Frontispiece: 'After its youthful surprise the beauties of landscape gradually reveal themselves as things of intimacy rather than strangeness, and one comes to conclude that the true fruit of travel is perhaps the feeling of being nearly everywhere at home.' – Freya in Nepal, 1970.

For Flocky and Fred

· CONTENTS ·

· PREFACE ·

Freya Stark is a legend in her lifetime. Like all legends it contains truths of many, and varied degrees of factuality. Much of the legend has been the work of Freya herself, through her voluminous writings, including four volumes of autobiography. I have carefully read most of her published work, but have not done any independent research: so this book in no way pretends to be a biography. It is a personal, and, I hope, affectionate tribute from a godson, not a critical account of her life.

I would like to thank all the people who helped in the preparation of this book or otherwise made it possible. I am grateful to Her Majesty the Queen Mother for gracious permission to reproduce the picture on p. 134; to John Murray for permission to quote from the following books: *The Valley of the Assassins*; *The Southern Gates of Arabia*; *Winter in Arabia*; *Traveller's Prelude*; *Perseus in the Wind*; *Baghdad Sketches*; *Beyond Euphrates*; *East is West*; *Coast of Incense*; *Dust in the Lion's Paw*; *The Zodiac Arch*. I would also like to thank Jock Murray in particular for his co-operation over the photographs, and for kindly reading through the typescript before publication; my wife Tiggy, Mark Lennox-Boyd, Gillian Grant of St Antony's College, Oxford and Francis Witts for photographs. Caroline Moorehead, Princess Joan Aly Khan and my mother, Pamela Cooper, helped shape my understanding of Freya and her work in conversation, as did Molly Izzard, her official biographer. I would like to record my thanks to Michael Stewart and Caroly Piaser for arranging several visits to Asolo and to Anna and Giovanna, Freya's minders, for looking after me there. My thanks also, to Eleo Gordon of Viking, whose encouragement and badgering got me to produce a text despite the demands of a full-time job in journalism. Above all, my thanks to Freya herself, for lending her photographs and for allowing me to spend so many pleasant and memorable days in her company.

London, September 1985

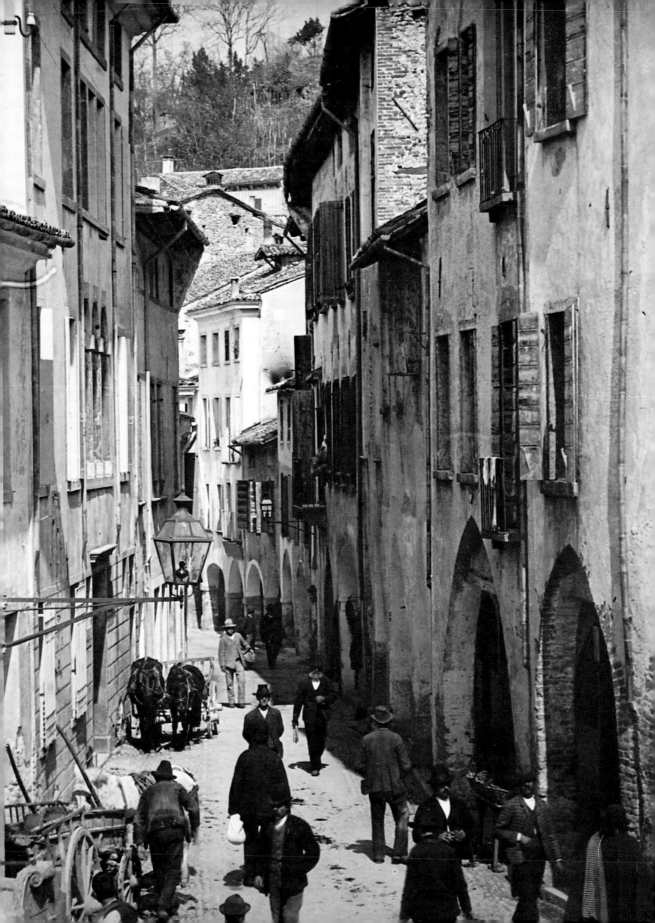

·1·
THE MAKING OF A TRAVELLER

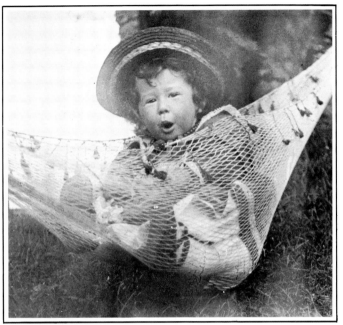

'MY EARLIEST CHILDHOOD is filled with memories of railway stations marching into darkness, filled with soot and roaring trains, and myself being rushed by some distraught, relentless adult hand – in the days before corridor trains were frequent – to find a lavatory somewhere.' Freya's father had a theory that children should replicate the stages of primitive man, just as in the womb they had gone through the various stages of animal evolution. Before they could barely walk, she and her sister Vera were well into the nomadic age. Freya was destined to stay there for much of her life.

She was born in Paris on 31 January 1893. Within a year she had travelled to Devon in England, visited her grandmother in Genoa and moved on to Asolo near Venice, the home to which she would eventually return from her travels

Opposite: 'Asolo lay anchored at my heart through all eastern wanderings.' – The Via Robert Browning, 1902.

Above: '. . . the first extraordinary sensation of being one thing when all the rest of the world is something else: a sad feeling which it takes us all the rest of our lives to dissipate.' – Freya, aged one year, 1894.

and spend her declining years. The pattern was to be repeated throughout her childhood and early life.

'My parents', she would write, 'were moderately well-off people with good taste.' The Starks of Torquay were members of a prosperous brewing family which had been established in Devon for a couple of centuries. Her father, Robert, was the youngest son of a scion of this family with properties in Torquay and Dartmoor. John, Robert's father, was considered to have married beneath himself and lived a somewhat austere provincial life with his wife's none-too-grand relatives. He did, however, allow Robert, who showed artistic talents, to study painting and sculpture instead of entering a 'respectable' profession such as law or medicine. Artistic blood ran in the family. John's brother William had become a painter and gone to live in Italy. In contrast to John, William was extravagant, romantically inclined, and highly gregarious. On spying a pretty girl riding in an open carriage in Rome, he engineered an introduction and succeeded in marrying her. She turned out to be the daughter of a German painter. She was fluent in three languages and had catholic tastes in reading. Their villa in Florence became a regular staging-post for the English literati. The Brownings, the Trollopes, the Thackerays and Landors all stayed there. So, of course, did young Robert, while doing the Grand Tour. He was so captivated by William's eldest daughter, Flora, his first cousin, that he proposed, was accepted and married her. She was only seventeen.

The marriage was not happy. Robert – or 'Pips' as he was known to his family – was a countryman at heart. Taciturn, inclined to reclusiveness, he loved to walk, garden, raise animals or otherwise communicate with nature in Wordsworthian solitude. His best paintings are lyrical celebrations of the countryside in all its seasons; his animal sculptures, at which he excelled, are rendered with the literal, detailed, eye of the naturalist. Flora – or 'Biri' as the children called her – was an extremely pretty, vivacious young woman, accustomed to being the focus of attention. Gifted in music and painting, she radiated a slightly ethereal charm. Robert brought her home to his house at Ford Park on Dartmoor; the provincial society bored her, and she so hated the rain that one afternoon Robert returned from a walk to find that she had closed all the shutters and lit all the candles. It was a refusal to face unpleasant facts that would be repeated, with disastrous consequences for Freya and her sister.

Robert and Flora moved to lodgings in London, near the Alma-Tademas in St John's Wood. Flora became the centre of a talented, admiring circle. She gave lively dinner-parties, and played the piano to appreciative audiences, which on one occasion included Franz Liszt. Robert taught for a while at Kensington Art School. But though highly thought of, he was too restless – and rather too well-off – to stick to a job. He bought and sold houses in Devon and Surrey,

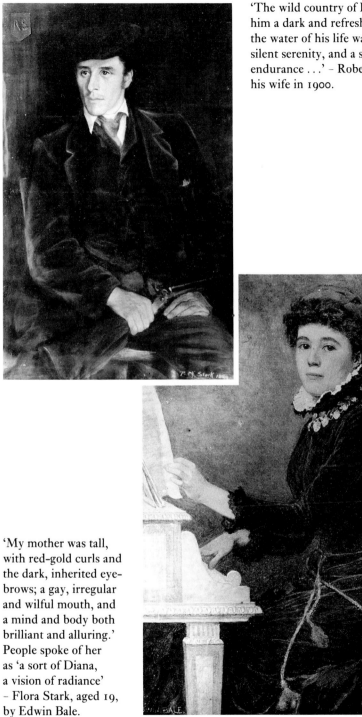

'The wild country of Dartmoor . . . was to him a dark and refreshing well from which the water of his life was drawn. It gave him silent serenity, and a sort of patient endurance . . .' – Robert Stark, painted by his wife in 1900.

'My mother was tall, with red-gold curls and the dark, inherited eyebrows; a gay, irregular and wilful mouth, and a mind and body both brilliant and alluring.' People spoke of her as 'a sort of Diana, a vision of radiance' – Flora Stark, aged 19, by Edwin Bale.

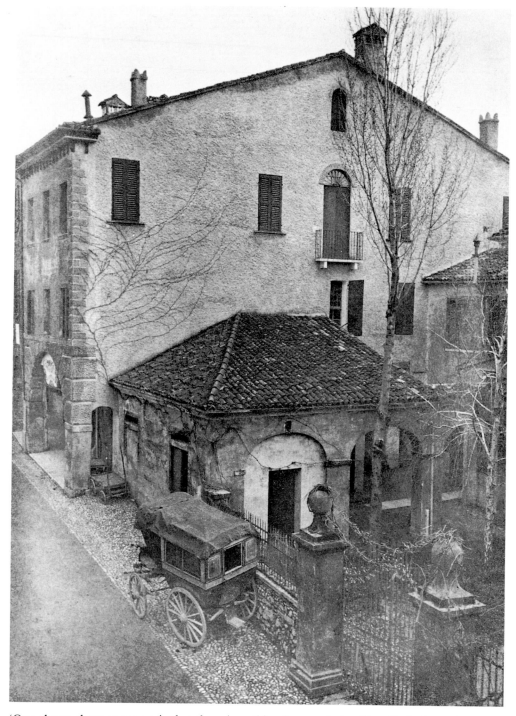

'One charm about our town is that there is nothing here to do.' – Casa Freia from the street, Asolo, 1902.

indulging a talent for landscape gardening. Then the couple moved to Paris –
to do some 'serious' painting; thence, after Freya's birth, to Asolo, where Vera
was born the following year.

Asolo is a small renaissance town of winding colonnaded streets and spacious
villas with gardens set on a hill above the Lombardian plain. Once the favoured
summer resort of Venetian merchants, it was 'discovered' by Robert Browning
in 1838. Half a century later – in 'Asolando' – he recalled the almost mystical
state in which he came upon the town, its two castles and pink campanile
transfigured in the noonday sun:

> 'How many a year my Asolo
> Since – one step just from sea to land –
> I found you, loved yet feared you so
> For natural objects seemed to stand
> Palpably fire-clothed . . .'

Robert Stark first came to Asolo, on the advice of the Brownings' son Pen
(who owned some houses there), during a walking tour with Herbert Young, a
student friend. Young, a genial dilettante and keen photographer, bought the

Pen Browning, son of the poet and Elizabeth
Barrett, had recommended Asolo to Robert
Stark and Herbert Young in the 1880s. He
had several houses there, as well as a palazzo
in Venice.

As children, Freya and her sister 'became
devoted to Herbert, taking for granted his
long-limbed, quiet manner and simple ways'.
Herbert Young took most of the pictures in
this chapter.

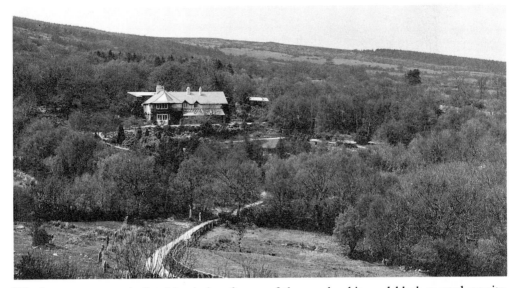

'The house was stone-built with window-frames of the rough white and black spotted granite of the moor ...' – Ford Park, near Chagford, last of several houses built by Robert Stark, *c.* 1910.

gatehouse next to the villa where Browning had sometimes stayed with his friend Mrs Bronson (also a friend of Henry James). He transformed it into a fine gentleman's villa lined with Morris wallpapers, and created a lush garden of rose-pergolas, shrubs and herbaceous borders of a kind that only the English or Dutch make in Italy. Flora and her children came there regularly, sometimes with Robert but increasingly without him. They also went walking in the Dolomites, and spent part of the summer in Dartmoor or France. Their early education was entrusted to a German fräulein, and an Italian governess, Contessina. They also regularly visited their maternal grandmother, who had moved to Genoa after William's death. (By the time William had died, in his forties, from the bite of a rabid dog, most of his fortune had gone in debts, and his widow was reduced to giving private lessons in literature to the young ladies of Liguria.) But after Ford Park, Asolo was the nearest thing to 'home' which Freya experienced; and it was in recognition of this that, many years later, the childless Herbert Young gave her the house with all its contents. Though it now belongs to the municipality, the name 'Casa Freia' is still engraved on the gateposts.

As the parents became estranged, the girls spent more time in Italy with their mother, though all three of them continued to visit Ford. Freya would be affected in many ways by the decline of her parents' marriage; but as a child she did not lack emotional security. The extraordinary trustfulness in all kinds

16

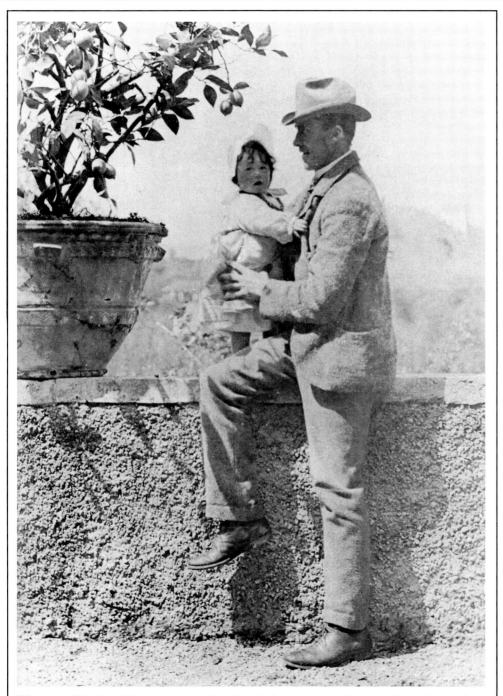

'He was well-knit, neither short nor tall, with a body whose muscles were all used and a face in which the grey eyes were remembered because they were so honest ... In his tweeds, shapeless and soaked with showers, he was at home.' – Robert Stark with Freya, 1893.

'My mother kept us carefully away from anything that might contaminate – servants, nursemaids or other children.' – Flora Stark with her daughters in Asolo, *c.* 1903.

'I had a reputation for naughtiness . . . which seemed to make me unjustly popular, for all my parents' visitors were ready to come and play at my games.' – Freya aged ten in Asolo, *c*. 1903.

'It is [the artist's] nature to avoid unpleasantness in a degree which in normal people appears extreme, and to excuse it by saying that things hurt him more than the uninitiate can understand.' – Robert Stark *c*. 1900.

of human being that Freya would exhibit on her travels, the fearless confidence with which she would ask, and usually receive, help from total strangers, suggests all the self-confidence of a much-loved child. Moreover, on the purely personal level this security enabled her to triumph over a series of accidents, illnesses, disappointments and bereavements without bitterness.

Freya remained devoted to her father until his death in 1931. In 1911, at the age of 52, he decided to sell up Ford Park and join his elder brother in Canada. Freya wrote to him regularly, and twice made the journey to his farm at Creston, near Vancouver. She remained his principal channel of communication with her mother. He instilled in her the classic Victorian virtues of physical toughness (never to cry when falling off a pony, for example) and self-reliance. She inherited much of his stoicism, his independence of mind, his English Toryism and, above all, his passion for landscape, especially mountains.

With her mother, Freya's relationship was inevitably more complex. She blamed her for ignoring and neglecting her father, for blindly following her

'Behind the villa, Monte Servo was powdered with snow. A foaming stream poured down from him in a canyon, spanned by a bridge which shook in the spray and was called the Ponte della Morte, the bridge of Death.' – Freya and her nurse at Belluno in the Dolomites, *c.* 1903.

own course of action without thought to the consequences. At the same time she became increasingly protective and assertive towards her, as if to make up for the guileless diffidence, so un-Victorian in this respect, with which Robert continued to indulge his wife. She became her mother's protector, her lover almost. It was to her that she would address the great majority of the letters, weekly or daily, from Syria, Iraq, Persia or Arabia, that are the raw material of her first, and greatest travel books. And it was over her mother's soul, as much as her father's money, that she entered the long drawn-out and bitter engagement that was to scar her, physically and emotionally, for life.

Her antagonist was Count Mario di Roascio, a small, round, tough Italian from a family of impoverished Piedmontese aristocrats. He had first appeared in their lives as a week-end guest at Ford Park. The girls disliked him instantly. Invited by Flora to join them walking in the Dolomites, they did their best to shake him off by luring him up rocky stream-beds and over precipitous ledges.

Opposite: 'I longed already with a passionate longing to climb all hills in sight.' – Freya at Belluno in the Dolomites, *c.* 1903.

Mario, however, was nothing if not persistent. In 1903, when Freya was ten, he persuaded Flora to take a house in his home town of Dronero near the Val d'Aosta. She intended to spend the summer there. Instead she remained for sixteen years, until after the First World War.

Mario had broken with family tradition by becoming an entrepreneur. He took over a small workshop making carpets, matting and basketwork from the local priests, who had used it to provide work for handicapped people. At first Flora offered advice, helping in the office now and then. But gradually she took over more and more of the business, obtaining money from Robert to invest in it. The factory, and Mario, became her life.

Was Mario Flora's lover? Freya thought not, at least in the technical sense, and others who knew them both agreed with her. Both Robert and Flora had shown strict middle-class Victorian attitudes in sexual matters. Robert suffered, from a distance, his wife's desertion, and never looked at another woman to his dying day. Divorce was out of the question. 'My mother', wrote Freya, 'was not only ignorant, but extremely un-sexual: not ascetic, which implies renouncement, but unaware ... It would have been better for us all, even for my father, if Mario or anyone else had been a lover indeed; it would have created gentleness and understanding; and would have done away with that fatal materialism in morals which relies on facts more than feelings, and gives a smug, unreal security.'

Freya's hatred of Mario grew with her mother's neglect. Her mother's voice became submerged in Mario's 'ceaseless monotone', his 'chanting endlessly, like a cock on a dunghill, the continuous saga of himself'. As his ascendancy over Flora increased, so his attitude towards the children became more dominating and possessive. Then in January 1907, shortly before her thirteenth birthday, Freya suffered an injury which, symbolically, added physical scars to the emotional ones wrought by Mario and his factory. A new works had been built and Mario was showing her round when a steel shaft caught her by the hair and whirled her off the ground, tearing half the scalp and mutilating one of her ears. Her survival, a miracle, was a tribute to a young doctor in Turin who had pioneered a new method of skin-grafting. But the scars remained for life, spoiling, in her own view, 'such looks as I might have had', though she carefully concealed them with hair set in place under hats or bonnets.

Opposite: 'The factory was a nightmare. The more it grew, the more substance it seemed to require, and the less it gave out.' – The factory at Dronero where Freya had her accident, *c.* 1905.

Inset: 'I do not think I regret anything except the coming into our lives of Mario – the only person of those with whom we were deeply involved whom I could truly dislike.' – Count Mario Roascio, *c.* 1940.

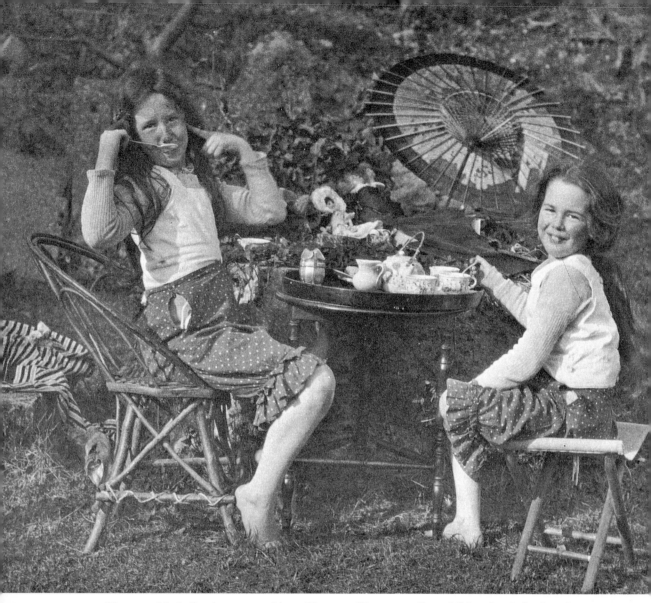

'Vera would gladly give me anything of hers ... She was a silent child and quietly thought out plans which I put into action and got the blame for.' – Freya and Vera, *c.* 1903.

Freya's accident, the first of several close encounters with death in her very long life, brought her mother closer; but life in Dronero continued as before, only worse. Robert decided to remain permanently in England. The local society ostracized Flora, believing her to be living in sin. Her English friends, none of whom could stand Mario, abandoned her. The factory consumed more and more of Robert's money, and more of her mother's time. The girls tried – and failed – to shake off Mario temporarily, by arranging trips to Paris or Florence, which he ruined, either by turning up, or by recalling Flora with some urgent telegram about factory business.

When Freya was 17 it dawned on her that Mario expected her to marry him. The thought disturbed her. He was the only man she knew, apart from her father, and at some level his presence had aroused her sexual awareness, if not her feelings. She also believed it to be her mother's wish, and was relieved when she found out that the idea had never entered Flora's head. In Freya's account, Mario made his somewhat oblique proposal when he joined her and Vera on one of their walks. 'Would you like us always to be like this – together?' he asked. 'No,' replied Freya, 'I think once a week would be enough.'

Thereafter, Mario turned his attentions to Vera, who seems to have been much less forceful than her sister, and had no will to resist. They were married in 1913 at a ceremony during which Vera was also received into the Roman Catholic Church. Freya, who shared her father's non-conformist views, tried but failed to prevent Vera's conversion. The marriage added bitterness to the conflict with Mario, whose possessiveness towards Freya and her mother now had a legitimate pretext. Vera was miserable, for despite the promise of a separate establishment, her mother continued to live with them. The struggle continued until after the First World War. Vera took over the factory in Mario's absence on war work, but Flora was always there, crushing her younger daughter's need for independence. The factory continued to swallow money, including £2000 that should have been Vera's.

Eventually, Robert intervened, like a benevolent *deus ex machina*. He bought Freya and her mother a little cottage on a piece of land at La Mortola on the Riviera, near the French border – a good eighty miles from Dronero. Vera and her four children came to bathe in summer, until Mario forbade this because Flora, under pressure from Robert and Freya, had reluctantly sued for the money – a third of the factory's value – that Mario owed her. By the time the case was settled, in Flora's favour, Vera was already dying. In 1926, after a two-month struggle, she succumbed to septicaemia contracted as a result of a miscarriage. 'She accepted her suffering', Freya would write, 'with the same quiet detachment with which she had faced her life ... I cannot help believing that if she had wanted life more, she could have held it: but she was not interested, and accepted death as she had accepted her marriage and her baptism, and no one outside her could help.'

* * *

In the isolation and unhappiness of Dronero, Freya had buried her sorrows by reading. Though without formal schooling, she was fluent in English and Italian. Her German, acquired from the fräulein and her grandmother, was good, and her French, polished by lessons at a convent school, was up to reading Dumas. Her knowledge of literature was acquired, haphazardly, from family

and friends. Her German grandmother read her the Bible, the Greek legends, the Siegfried sagas, Dante and Goethe; Herbert Young introduced her to Mallory and Shakespeare, Scott and Stevenson. At 14 she began to teach herself Latin; by the time she was 17 she had read Plato, Spenser, Milton, Hazlitt and Jane Austen. Her father inspired her to read *The Origin of Species* and other books on evolution, and it was perhaps characteristic of her parents' pre-Freudian world that it was from Darwinian theory that she had to infer the 'facts of life'. She wrote sensitive, rather formal verses, and tried her hand at stories, finding her purest pleasures in playing with words. Nor was she unversed in more practical skills. She took over much of the housekeeping from her mother, and acquired a knowledge of arithmetic by keeping the books at the factory.

In the autumn of 1912 she enrolled at Bedford College, a women's college attached to London University, having passed the matriculation examination the previous summer. A day-student, she boarded with Viva and Harry Jeyes, friends of her parents from St John's Wood days. Jeyes was a well-known journalist, assistant editor of the *Standard* and an influential figure in political circles. His wife, wrote Freya, 'had a delicate beauty, with hair like fine gold, and wore the sort of gowns that we had forgotten'. Freya attended lectures by Professor Allen in History, but the teacher who made the greatest impression was W. P. Ker, whom she had previously met with the Jeyes. Ker was a taciturn, fastidious, Scots bachelor in his sixties, a specialist on medieval literature and author of a classic on the subject *From Epic to Romance*. With her father now in Canada, he became the leading influence in her life. She adopted him as a 'godfather', and would probably have married him – like Dorothea in George Eliot's *Middlemarch* – if only he had asked. 'W. P.' as he was affectionately known by his students, was an immensely popular professor. His lectures at the University College theatre were packed. Students would signal their approval by stamping their feet in anticipation of his arrival. (He invariably started late, on the principle that no lecture should last more than forty-five minutes.) At first Freya adored him from a distance, too shy to approach him directly. But, knowing Viva Jeyes, Ker took to inviting them both to his house in Gower Street. There was no electricity: 'only candles were allowed to light the branching Morris wallpapers and piles of books on every floor and landing'. W. P. became Freya's literary mentor, encouraging her writing. She never forgot the pain when he wrote on one of her essays 'Too many words', or the ecstasy when, on showing him a chapter from a manuscript on Italian history, he silently put the pages down and kissed her. W. P. took Freya on walking tours in Scotland, and taught her to climb with a rope in the Alps – a singular concession, since he generally disapproved of women climbers. But he was no misogynist. He enjoyed the company of several other young women – causing

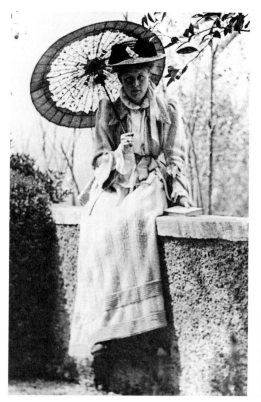

'She had been lovely when young, with London at her feet, and never guessed at the difficulties of anyone as insignificant, shy and foreign as I was.' – Viva Jeyes in 1913.

'W. P. Ker, who was to mean more to me than any other person for many years of my life . . . He taught me all I know in English Literature.'

Freya to write peevishly to her mother, 'The dear Professor is always dear, but he has too many god-daughters. A new one every time, and he produces them without the rudiments of tact.' In July 1923 Freya was climbing with him and two other god-daughters near Monte Rosa, when he died suddenly of a heart attack. She always kept his picture in her living-room. 'The grief for W.P.', she wrote, 'was not bitter, for he has never seemed far away or really separated by death.'

<p style="text-align:center">* * *</p>

The outbreak of war in August 1914 found Freya in Italy which, though neutral, was expected to come in later alongside Britain and France. Freya abandoned Bedford College, and decided to enlist as a nurse to be near the action. Her failure to acquire a degree did not disappoint her. She had changed from reading English Literature to History because she got more pleasure from

<p style="text-align:center">27</p>

immersing herself in original sources than literary criticism. But she did not have the temperament of a serious academic historian: she was too adventurous, imaginative and inattentive to detail. She began her nursing training at a clinic in Bologna. Overcoming her natural squeamishness, she picked up the work so quickly that within a month she was allowed to administer chloroform. Once she fainted after giving an overdose to a patient with a weak heart who had to be revived with artificial respiration. The young doctor who picked her up said, 'You must not get so agitated, signorina – we have all killed somebody.'

At Bologna she was courted by Guido Ruata, a bacteriologist nearly twenty years her senior. They became engaged, but soon afterwards Freya fell ill with a mysterious wasting disease which eventually turned out to be typhoid. Guido's ardour cooled, he obtained a new post and broke off the engagement. Freya was mortified, but tried to shield him from blame, even when she found out that he had married his former mistress. Her mother added to her agony by threatening to take Ruata to court over a portrait Freya had given him, and which he eventually returned. Freya had believed herself to be deeply in love; but perhaps subconsciously she rebelled against marriage, and hence her illness. Nevertheless she hankered after marriage – and would continue to do so – for both conventional and personal reasons. She wanted the social acceptance and respectability that only marriage gave to women in those days; and her appearance, even without the accident, must have given her a sense of inferiority *vis-à-vis* her mother and sister. She was endowed with most of the qualities which society respects – charm, wit, brains and courage. But for a woman, these things counted for little unless she was beautiful as well – at least in the society to which her mother had once belonged, and to which she herself aspired.

In 1916 Freya returned to England. Still weak from her illness, she worked as a censor for a time before resuming her training as a nurse. After six weeks, she was accepted as a volunteer in an ambulance unit organized by the historian G. M. Trevelyan. It gave her the only chance she could find of reaching the Front. By September 1917 the unit was installed at a villa in Udine, just in time to witness the traumatic defeat of the Italian army at Caporetto. For the first time, Freya assisted at an amputation. 'It is a strange and shocking thing to feel a limb become suddenly lifeless in one's hands,' she wrote. 'I think I saw why nurses are nearly always happy people: their life is a constant drama, with no interval of boredom – people are always recovering or dying.' Freya's unit was among the last to leave Udine, abandoned to the invading Austrians and Germans. They joined the retreating hordes moving southwards to Padua:

'The great roads, running along raised dykes, were filled with traffic, three-deep and no control: on the second day we did one and a half miles in twelve hours: our driver

never slept, every half hour or so the column gave a jerk, a few yards would be gained. The infantry were all dispersed, marching weaponless across country, or plodding under strange loot – a goose, a cello, piles of clothing. The wounded trailed along with stained bandages ...'

The ambulance unit disbanded, Freya returned to Dronero, where she sat out the rest of the war. The post-war years were a period of poverty and reconstruction – for Freya and her mother, as for most of Italy. While the struggle with Mario moved into its final, legal phase, they set themselves up in the home which Robert had bought at L'Arma, near La Mortola. Here Freya's preoccupations were chiefly financial. She had an income of £90 a year from money given by her father. Her mother ought to have had enough to live on, but all of it was tied up in Mario's factory. Money became a nightmare: 'I used to lie awake at night and wonder how the next week's food could be supplied, and ponder over cheap, filling things like potatoes.' She planted the two acres with vines and flowers for marketing. She bought a milch-goat. They built on to the cottage and Flora decorated the new rooms with frescoes. Freya tried unsuccessfully to increase her income by gambling at Menton on the French side of the border. She was more successful at contraband and earned £100 by smuggling an early Siennese Madonna to France for a collector. But despite their comparative poverty, there were agreeable social diversions. The Oliviers, family friends, arrived on a visit, and were so enchanted with the place that they bought the neighbouring property. There were new Italian friends as well – the de Bottinis de Ste Agnes. Gabriel, the younger son, was set up by Flora and his own family to marry Freya. But by the time he got round to proposing, her thoughts had already turned to the East.

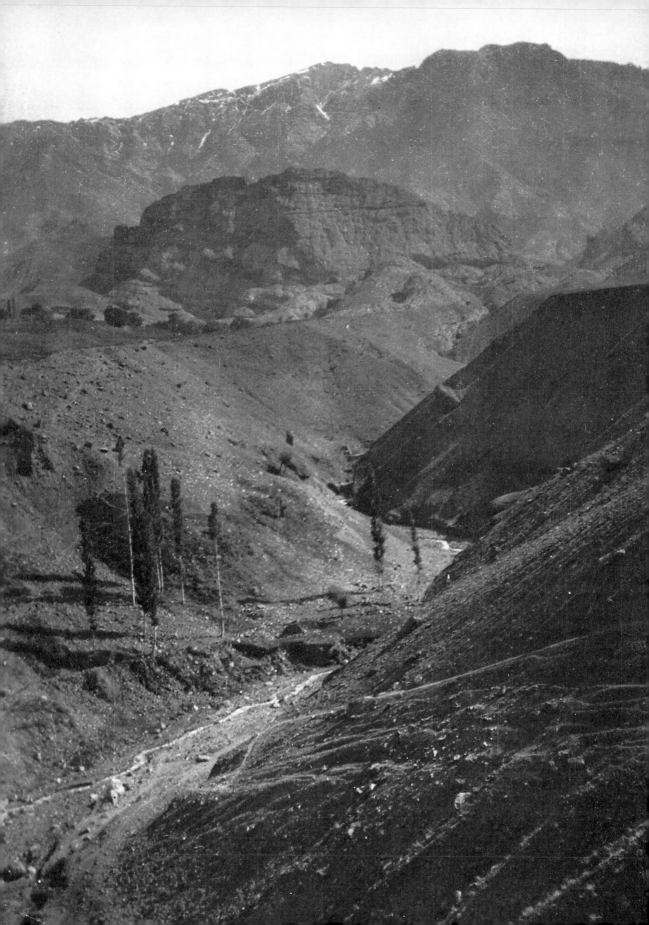

·2·
THE GREAT JOURNEYS

'But the majestic river floated on,
Out of the mist and hum of that low land,
Into the frosty starlight, and there mov'd,
Rejoicing, through the hush'd Chorasmian waste,
Under the solitary moon.'

(Matthew Arnold, 'Sohrab and Rustum')

IT WAS W.P.'S VOICE which etched these lines into Freya's memory. Years later on a visit to Central Asia she would recall them, and so hypnotize a Soviet guard – with an unexpected passion for English literature – that he let her visit the forbidden Oxus. This river – beyond which Asia stretches in endless steppes, open to merciless waves of horse-borne invaders – was for

Opposite: 'The castle rock is always in sight and as you come near you see what a magnificent position it was. Romantic isn't the word. It holds the whole enormous fortified valley, over-looking it from one end to the other over the lower ranges, across the tilted pasture-desert to the snowy range of Elburz ...' – The Rock of Alamut, 1930.

Above: 'Some day I must make a list of the reasons for which I have been thought mad and by whom ... It was almost as hard to persuade the Assassins that I come to their country for pleasure as it was to persuade the British Civil Service.' – The way to Alamut, 1930.

31

millennia the last frontier of the civilized world, the place where Greeks, Persians, Romans and Muslims tried, not always successfully, to draw their frontiers. An almost mystical desire for freedom inspires the Westerner who ventures in search of such limitless vastness. 'The charm of the horizon', Freya would write, 'is the charm of pilgrimage, the eternal invitation to the spirit of man'. But she recognized, too, that the impulse towards freedom and adventure has its negative side. She needed to escape, as she put it, 'the unusually harassing surroundings of my youth ... into an emptier, less fretful life', and try to shake off the burden of illness that constantly plagued her following the bout of typhoid suffered at Dronero in 1918. 'I had made up my mind that I would rather die than go on living as an invalid.'

For Freya, the East meant 'space, distance, history and danger'. She began to learn Arabic at l'Arma in 1921. Her first teacher was an old white-bearded Capuchin monk from San Remo who had been thirty years in Beirut. W.P. would have preferred Icelandic; but Freya determined on Arabic, because of the breadth of the world it covered and because she foresaw that the development of oil must lead to interesting opportunities. On visiting London in 1926 she took private lessons at the School of Oriental Studies; later her teachers included such distinguished orientalists as Sir Denison Ross and Laura Vecchia Vaglieri.

By the end of 1927 a combination of good housekeeping and a fruitful investment in Canadian railways brought her income up to the target she had set of £300 per year. Though still in delicate health, she set off to continue her Arabic in Lebanon, at that time part of the territory mandated to France under the post-war settlement. She took rooms in Broumana, a village of neat stone houses in the pine trees above Beirut.

She moved to Damascus, where she stayed with a Syrian family, and first experienced the life of a traditional Muslim household. In May 1928, accompanied by her friend Venetia Buddicombe who was returning to England from India, she made her first 'difficult' journey – to the Jebel Druze in the Syrian desert south of Damascus. The area was under martial law, following an abortive Druze rebellion against the French, and, typically, Freya and Venetia stole into the Jebel, with their Druze guide, without seeking permission. The Druze – an offshoot of the Ismaili branch of the Shia – were fiercely independent. In the nineteenth century they had sided with the Ottomans and the British against their French-backed Maronite rivals – which perhaps explains why the two Englishwomen were thoroughly well-received, attending a wedding and spending two days as guests of a senior Druze divine. The French authorities were none too pleased when the two ladies emerged unscathed from what was supposed to be a wild and ungovernable part of their territory.

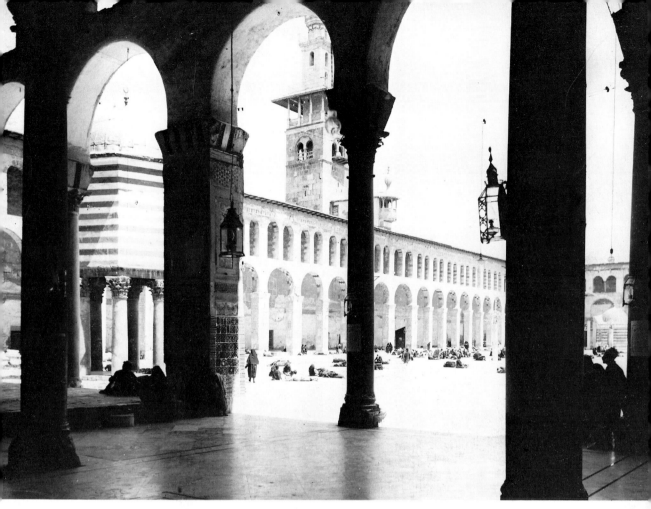

'My sheikh has taken me over the Great Mosque, a wonderful, beautiful place to pray in ... It is immense. The general effect is absolutely simple; there is nothing to take the eye or thoughts away. The people wander in to pray or talk quietly. All the political plots were hatched here.'
– The Great Mosque, Damascus, 1928.

There were trips to Jerusalem and Egypt of the more conventional, touristic, variety. Then Freya returned to Europe and went on to Canada to see her father. An article about the Druzes – her first published work – appeared in the *Cornhill Magazine*. Her appetite for 'difficult' journeys now thoroughly aroused, Freya resolved to move further to the East. She read Gertrude Bell and St John Philby, and met the cousin of the great Arabian explorer and travel-writer, Charles Doughty, who had died in 1922. Then in 1929 she journeyed to Baghdad, to improve her Arabic and to start learning Persian and other eastern tongues.

She arrived three years after the death of Gertrude Bell, the famous traveller and friend of T. E. Lawrence, who had held the post of Oriental Secretary, acting as godmother to the new Iraqi kingdom. But Freya, who disapproved of

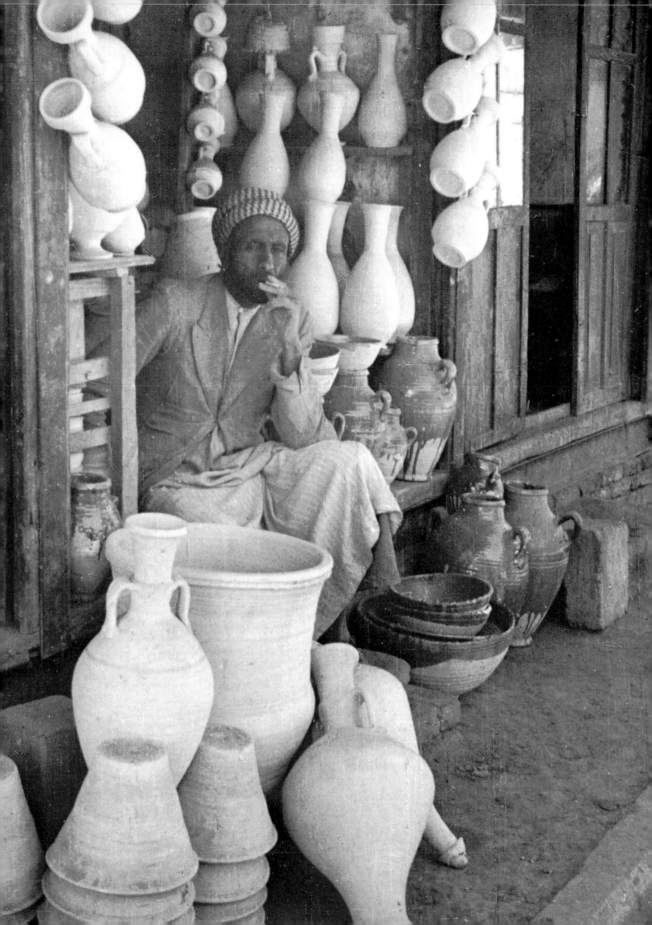

Bell's rather grand style of travelling with an entourage of servants, did not greatly regret missing her. Knowing of Bell's reputation for not liking many people, especially other female Arabists, she doubted if the great lady would have been kind to her. But Bell's departure certainly left room for a successor. 'I feel that I really may end by doing something,' she wrote to her mother in 1930, 'only it is not a thing that can be hurried. But in three years time I could learn enough Persian, Turkish, Kurdish and Arabic to get about, and I believe I would be the only Englishwoman in the Near East to do so; and then something amusing is bound to turn up.'

Baghdad was a mixture of beauty and squalor, satisfaction and frustration. After centuries of provincial stagnation under the Ottomans, the city of the Arabian Nights and former seat of the Abbasid caliphs was a capital once more, though no longer that of an empire. Mandated to the British at the San Remo conference in 1920, the territory of Mesopotamia had reverted to its former Arab name, Al-Iraq, and had been provided with an Arab king, Feisal, son of the Sharif of Mecca and leader, with T. E. Lawrence, of the famous Desert Revolt against the Turks in 1916. Under British tutelage the city was expanding, having acquired a pontoon bridge over the Tigris and a modern 'high street' of asphalt and new shops alongside the traditional Arab town. The British underpinned a Westminster-style parliamentary monarchy (complete with plumed hats and open Landaus) with modern communications and a range of public works, and provided a large staff of bureaucrats, engineers and teachers. The mass of the population – a heterogeneous collection of religious and ethnic groups, including Arabs, Kurds, Assyrians, Bedouins and Farsi-speaking Shi'ites – went about their business in the traditional way – apart from a burgeoning, secular-minded nationalist bourgeoisie whose desire for leadership was frustrated by the British presence.

'This morning was again old Baghdad of the Arabian Nights,' wrote Freya in her diary in November 1929, 'the hanging painted balconies, the streets opening and narrowing in surprising, sudden ways, the flapping white gown with bare leg showing through its slit side, the turban with bit of fringe falling on the neck, the shadows which are still pervaded by the intense sunlight above ... Then, leaving the old mullahs with children round the Quran under trees, I walked into the modernity of Mrs Kerr's school, all clean – and yet neither East nor West, and though change must come, and our British variety seems

Opposite: 'I have just been living in the Arabian Nights – wandering in the bazaars: sitting on the ledge of the little shops while the merchant in his long gown spreads out his silks before me and the merchants opposite, with their amber beads like rosaries, clicking their fingers to pass the time, looked on at the ritual transaction.' – Baghdad potter, 1937.

better than the French, one can but wonder what these Western waves are really bringing ... Home by the coppersmiths' souq. Hardly ever see British off the main road ...'

Freya rented a room, for one shilling a month, from a shoemaker in the traditional Arab part of the city. The whole of one wall was made up of a window overlooking the Tigris, so she could watch 'the ancient boats go up and down just as if they came out of textbooks of Assyrian history'. Here she would entertain Iraqis and those more adventurous English people who became her friends. For she found – to her consternation – that she was far from being universally popular among the British officials and their wives. To live in the 'native' quarter was 'not done' for an English woman in Iraq in 1930; and she was often snubbed or made the subject of unpleasant innuendo. Matters were made worse when she accepted an invitation to visit a desert sheikh in the country, a cousin of her teacher's. She was advised to abandon the trip, and two possible women companions were pressured by their husbands not to go. Eventually she did find a companion, the wife of the legal adviser to the Iraqi government who spoke fluent Arabic. But the episode, so reminiscent of Forster's *A Passage to India*, helped her come round to a reluctant acceptance of the necessity for Iraqi independence. At heart, Freya would always remain an imperialist. She believed strongly in the virtues of British administration and British justice; and she was not convinced, at least in the beginning, that the Iraqis, despite the clamour of the nationalists, were yet ready for self-rule. But her vision of Empire was like Kipling's, the benevolent mixing of peoples and races under the rule of an enlightened, disinterested, British élite. Having grown up among artists and free-thinkers who treated the whole of Europe as their playground, she could never understand, and was genuinely shocked by, the petty snobbery and philistinism of many of the British officials she encountered, and especially their wives. She regarded the women as being responsible for humiliating the educated Iraqis by keeping them out of the British clubs, and this she saw as a betrayal of their mission. Only about two out of a thousand British people had any interest in mixing with the natives. 'We should so like to be allowed to love the English, if they did not always make us feel they were snubbing us,' a Syrian woman teacher, a graduate of Columbia University, had told her. 'I fear it will be very hard to keep in favour with both Arab and British,' Freya concluded, 'and the tragedy is that we seem to have brought a whiff of our own snobbishness among the Iraqis: I find that those I come upon independently are much nicer and more genuine than those I know through British introductions.'

By the spring of 1930 Freya felt that her Persian was good enough for a journey she had long been planning to the castle of Alamut in the Elburz

36

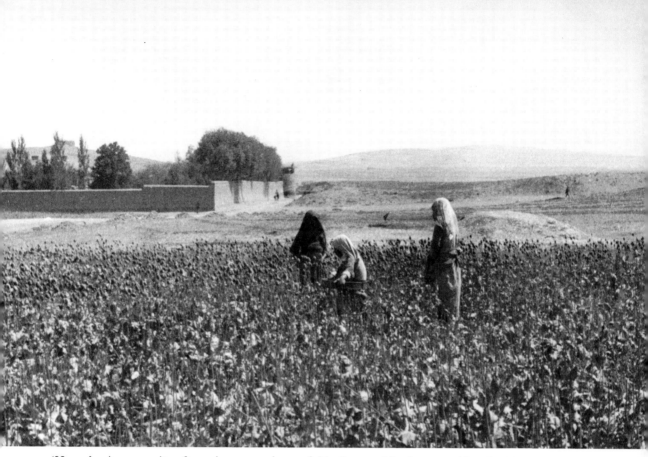

'Hamadan is now a city of poppies; everywhere a field of great white flowers, with a few mauve ones among them, stands out in the foreground, with the mountains and their last patches of snow behind . . .' – Hamadan, 1930.

mountains south of the Caspian. She had read the classic account by von Hammer-Purgstall about how the Assassins – an offshoot of the Ismailis, spread murder and mayhem throughout the Near East on the instructions of the Old Man of the Mountain, who stupefied them with hashish (hence the derivation of 'assassin' – from 'hashashin' – hashish-takers). The legend, brought to Europe by the Crusaders and recounted by Marco Polo, has always been popular, among Muslims hostile to the Ismailis as among Christians. Scholars have since dismissed much of the story – including von Hammer-Purgstall's version – as anti-Ismaili fabrication; but it is doubtful if Freya's desire to visit the famous Assassin stronghold of Alamut would have been dampened if more accurate accounts of Persian Ismailism had been available to her. Even without the details of the Old Man of the Mountain, with his garden and squads of drugged automata, the story is a fascinating one. Alamut – until its destruction in the Mongol invasions late in the thirteenth century – had been the headquarters of the Nizaris, a militant sect of the Ismailis, who waged war on the Sunni Seljuks

37

by assassinating their commanders – causing these semi-nomadic bands, which were bound together by ties of personal allegiance, to dissolve. Alamut's most famous ruler, who may have inspired the legend of the Old Man of the Mountain, was Hassan-i-Sabbah, a philosopher whose enlightened approach to Islam scandalized the pious. One of his successors went so far as to announce the 'resurrection', declaring the Sharia law suspended. Though the Nizaris later reverted to more orthodox teachings, their reputation as dangerous fanatics remained – at least until their latter-day Imam, the Aga Khan, established himself in India and adopted the manners and customs of the British aristocracy.

Unlike Syria and Iraq, where the Mandatory Powers protected Europeans, Persia was an independent country that was only now being retrieved from years of lawlessness with the advent of the firm rule of Reza Shah Pahlevi, a former sergeant in the Cossacks who became monarch in 1925. Reza Shah was an autocrat who used strong-arm methods to drag his people out of their comparative isolation and into the twentieth century. In order to weld his Kurdish, Turkish, Azeri, Lurish, Baluchi, Arabic and Farsi-speaking subjects into a single homogeneous nation, he abolished local particularities of dress, forcing men to adopt a round-peaked cap known as the Pahlevi cap. By means of a disciplined army and police force, he managed to effect his sartorial decrees even in remote mountain districts like the Alamut valley.

'... the police shows a Government letter and says they must all take to European clothes in five days' time ... two handsome wild-looking Lurs come along, one hatless: his felt cap had been seized and torn to bits, to impress the fact that Pahlevi hats are now the fashion. I suppose it is all right to civilize people, but it is a horrid process.' – Luristan, Persia, 1931.

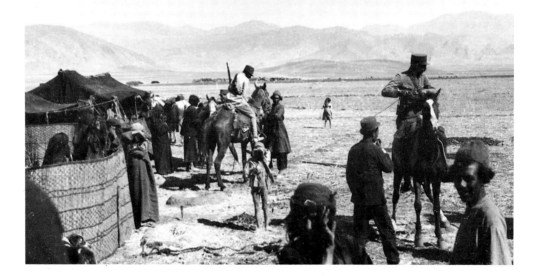

In April 1930, the month Freya crossed into Persia, the deadline for the new dress was imminent. Freya planned her first expedition as a solitary European woman with the same long-term efficiency she had learned in the Alps. She spent nearly a month at a hotel in Hamadan – 'a poor little mud and brick town of low houses and cobbled streets' – 6000 feet above sea-level, trying to improve her Persian; she took long walks and rides among the apricot blossoms, getting fit, trying out her Persian on peasants and impressing the local mullah with her knowledge of the Quran. But she was sometimes lonely and depressed, and at 37 was beginning to regret the passing of youth. 'To be just middle-aged with no particular charm or beauty and no position is a dreary business,' she wrote to her mother in a rare moment of self-pity. 'In fact I feel as if I had been going uphill all the time to nowhere in particular … most dreadfully lonely, envying all those women with their nice clean husbands whose tradition is their tradition, and their nice flaxen children who will carry it on the same simple and steady way … No one any longer makes love to me except when they are drunk.'

Owing to a hitch, she ran short of money, setting out from Qazvin, the last town before the mountains, with only £2. Once on the way, however, she cheered up, fortified by the Persians, including the police, who thought, 'nothing could be more natural or commendable than that one should travel from

'Being already completely bankrupt and unable to pay my hotel bill, I felt no hesitation in buying a string of ancient lapis lazuli beads of all odd shapes and sizes dug up from the ground. I can get any amount of cornelian necklaces for about three shillings each if you want them …' – Hamadan Bazaar, 1931

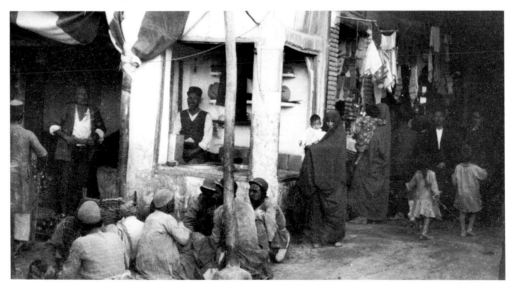

London to visit the castle of Hassan-i-Sabbah, and look upon me as a sort of religious pilgrim with great respect. The muleteer says he is going to be "like a mother to me".' They climbed the 10,000-foot Chala pass through hills of flowering thorns, and followed the Alamut river into the almost impregnable valley. 'The whole place gives one the feeling that, walking down into it, you are in a closed place shut off from all the world.' At the head of the valley, where they spent the night in the house of a doctor's family, they could see the castle rock standing out from the concave mountain, 'like a ship, broadside on'. They climbed up the rock, and inspected what was left of the castle – fragments of buttresses, walls and tunnels, evidently just a completion of the natural defences. There were shards of blue-glazed pottery, but otherwise few signs of human habitation after more than six centuries of desertion.

Freya and her guides returned to the entrance of the valley, and then turned left up the next valley, heading northwards towards the Caspian. The place had an idyllic, medieval quality – 'village touching village with dark green fields of

Below: 'The carpet was spread; we sat and ate water-melons and figs and pomegranates so delicious you would not know them from the horrid little things full of seed one has in Europe. They got out their opium pipes, and a brazier was brought, and we were all as happy as can be.' – Near Saveh, Persia, 1931.

Opposite: 'We have come down into the Chalus Valley, only to find all its villages deserted and so strange; the crops standing; wild figs and vines, a cat and a donkey wandering about alone ... It is a hard, lonely country. We have not met a single wayfarer on the road since we came down to it: all the life is now in the high pastures ...' – Chalus Valley, Persia, 1931.

41

Above: '. . . here in Kalar Dasht one really comes into the tradition of an old prosperity and finds buildings designed for ornament as well as comfort as good as many a country cottage in the Alps.' – A house in Rudbarek, Persia, 1931.

Left: 'The herdsman's boy, a light-haired Gilaki lad with small features, fair skin and beautifully-shaped Nordic head, appeared out of the seemingly uninhabited solitude to look at us as we lunched under a thorn tree.' – Jungali shepherd, Persia, 1931.

42

corn and little terraced lakes where the baby rice is growing'. The peasants in their round caps and tight waistcoats reminded her of figures from early Italian frescoes. 'It has been a wonderful time altogether', she wrote to her mother, 'and I can *see* how the story of the Assassins really was; can see the life here in the valley and the devotion of their people, and the remoteness from all the world: and the comparative well-being which there still is, though it has to be practically independent from all outside.'

She climbed to another, more complete, Assassin castle at Nevisar Shah before descending to the village of Aziz, her guide; then down through narrow, wooded valleys of tall trees and rushing streams that reminded her of the Pyrenees; until they finally came to the Caspian, lying quiet and dull beyond a landscape of paddy fields, oranges and flowering pomegranates that seemed to come straight out of a Japanese lacquer tray.

After visits to Europe and Canada, where she saw her father for the last time, Freya returned to the Alamut area in August 1931. She made some maps of the region, having learned the rudiments of this skill from the Royal Geographic Society in London, and discovered a third Assassin castle, known but as yet unidentified, at Lamiasar.

This castle, perched over a high ravine, was inaccessible to mules, and Freya scrambled up to the summit (described by a later expedition as 'inaccessible') in her stockinged feet. Returning by way of Alamut, she fell desperately ill from malaria and dysentery, and would certainly have died, but for the discovery of a doctor five hours ride away, who came to her and administered massive injections of quinine, and took her back to his village to recuperate. Here she regained her strength sufficiently to plan an assault on the Throne of Suleiman,

'You wouldn't believe so many different things would be wrong with one car. The first breakdown always occurs just outside the town, and is a sort of indispensable beginning to a Persian journey. Then we had a more alarming trouble: the screw which kept the back wheel on: whether lost or unsafe I don't know, but we went on, looking back at intervals, to see if the wheel was still there.' – Near Malayer, Persia, 1931.

at 15,000 feet the third highest summit in Persia, as yet unclimbed by Europeans. Her plans, however, were frustrated by the machinations of a Hungarian engineer, who warned her guide of the dire consequences that would be visited on him and his village if the unscaled peak were conquered by a European woman. Keeping his plan to himself, the wily Persian led her to a ridge from where the summit was inaccessible, instead of showing her the easier route to the top.

Freya returned, disappointed, to Qazvin, and then went on to Tehran, where she learned of her father's death. She visited Qom, Persia's theological capital, Isfahan and the medieval caravan-city of Saveh. In the Tehran bazaar she came across some bronze-age figurines which, she learned, came from the unexplored region of Luristan, near the Iraqi frontier. This was a wild and dangerous place, where, until Reza Shah had pacified the area three years previously: 'one was murdered for half a toman'. Unable to resist such a challenge, Freya decided to return to Baghdad by way of Luristan, to see if she could find some ancient graves and more statuettes. A letter to the governor got her safely to Alishtar, capital of North-west Luristan; but it turned out that the bronze-age graves were in a different part of the country. She returned to Baghdad and arranged a new expedition the following autumn. Shortly before setting out, she met a young man from the area, the nephew of a chief, who had been

'The handsomest people in Baghdad are the Lurs of Pusht-i-Kuh. They stride about among the sallow-faced city Shias in sturdy nakedness, a sash round the waist keeping their rags together ... you will think them the veriest beggars, until one day you happen to see them shaved and washed and in their holiday clothes ... and find that they are proud and have as much influence in their own country districts as any member of a country family.' – Baghdad, 1957.

44

'They are a wild people ... the men in their white felt coats and caps with locks sticking out under them and fierce eyes and meeting eyebrows ... driving down their goats and sheep and cows ...' – North-west Luristan, 1931.

educated in Europe. He promised to show her a hoard of gold ornaments, daggers, coins and idols hidden in a cave, and they arranged a secret rendezvous, planning to enter Luristan separately in order to avoid arousing the suspicion of the authorities. Freya slipped across the Persian border illegally, as her guide had no passport. They reached the area of low hills and scraggy oak-trees where the Lurs tended their flocks and in lean years were sometimes reduced to living off acorns. She found some graves, probably early Muslim ones, but discovered nothing of value. She took a skull, for identification, which she placed in her saddle-bag. Then she ran into a group of mounted police, who insisted on taking her back to the district governor – not, however, before she had managed to elude her escort for long enough to hunt for the secret cave among the scrubby oaks and ravines. But neither the treasure, nor her Lurish accomplice who had failed to make the rendezvous, could be found. On her arrival at Husainabad, the district capital, the governor was amused, and asked how she had lived in a wilderness so notorious for banditry. 'No wonder', said he, 'that yours is a powerful nation. Your women do what our men are afraid to attempt.'

45

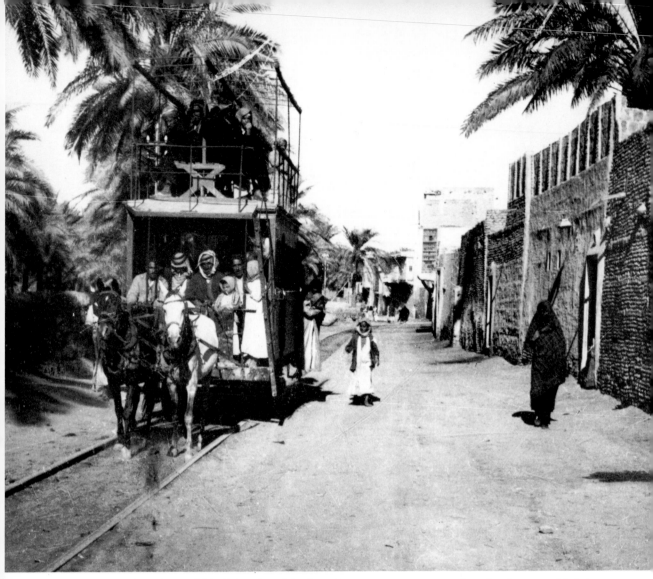

'... the effects of Turkish rule might have been even more severe but for the record left by Midhat Pasha, whose name is still remembered as one of the great rulers of Baghdad. In three years, 1869-72, he laid in Iraq the foundations of the modern age ... a tram horse-drawn along rails to Kadhimain, the Holy City, still bears witness to the great Pasha's now, antiquated modernity.'

Instructions arrived from Tehran saying that Freya must be escorted back to the frontier as soon as possible. On arriving in Baghdad, she found that her 'accomplice' had been arrested on a trumped-up charge, due to the machinations of an enemy who was also after the treasure. The same man had bribed six porters from the bazaar in Baghdad to intercept Freya; and in the wilderness of Luristan she could easily have been murdered without the culprits ever being discovered. Fortunately for Freya rumours had reached the Persian police that a strange foreign woman had been wandering about Luristan opening graves

46

filled with infidel skulls of solid gold. They had acted before her potential murderers had caught up with her trail.

It was in Baghdad that Freya first developed her skills as a writer. Often separated from friends and parents, she was always a prolific correspondent. 'Absence', she would write, 'is one of the most useful ingredients of family life.' A penchant for aphorism, one of the hallmarks of her style, is present even in her earliest letters. ('The French bourgeois', she wrote in 1923 from a hotel in Carcassonne noted for its cooking, 'has everything in life to make him happy except beauty in his wife, and that is a dubious happiness.') In Baghdad, for the first and only time in her life, she became a journalist. The slump in North America left her short of money, and she took a job as a sub-editor on the English daily *Baghdad Times*. Her main task was to put the news, culled from the BBC, the *Daily Mail* and Reuter telegrams 'into English', with suitable headlines. She learned the art so rapidly that six hours work were soon reduced to three. She quarrelled with sloppy adjectives and sometimes indulged in facetious headlines: in a Reuter report that the money from the introduction of death duties had been less than expected owing to the abnormally low mortality in millionaires, she decided that 'abnormally' was a poor sort of adjective and substituted 'regrettably'; unfortunately, neither this inspired piece of editing, nor her headline over a story about a science professor who died during a lecture after mistaking a tumbler full of acid for a glass of water ('An Absent-Minded End') were allowed by her editor, though he appreciated her skills enough to offer her, years later, 'a job at any time'.

Unlike Dr Johnson, however, Freya never believed in writing for money. Even in her poorest days, she averred, financial considerations had nothing to do with her books, which she wrote for pleasure and to record her travels for posterity. 'If I had to work for my living altogether,' she would write, 'I would not be a writer but a cook, and would write for my own pleasure after the dinner was served.' The *Baghdad Times* nevertheless served her in one important respect, by publishing a series of impressions, later assembled into a book, her first, under the title *Baghdad Sketches*. The style of these early pieces is unmistakable. The naturally lucid elegance of her letters ('Her sentences', wrote Patrick Leigh-Fermor, 'always fall on their feet with a light, spontaneous and unfaltering aptness.'), the verbal precision, the carefully chosen metaphor and the grandiloquent sense of history – characteristics of style which won her literary acclaim far beyond her achievements as a traveller – are all present in this passage on the fasting month of Ramadan in Baghdad:

'It is always strange and like a dream to walk in starlight among the narrower ways ... But now in Ramadan it is fantastic. The whole city rustles and moves and whispers in its labyrinthine alleys like a beehive swarming in the dark. One cannot distinguish

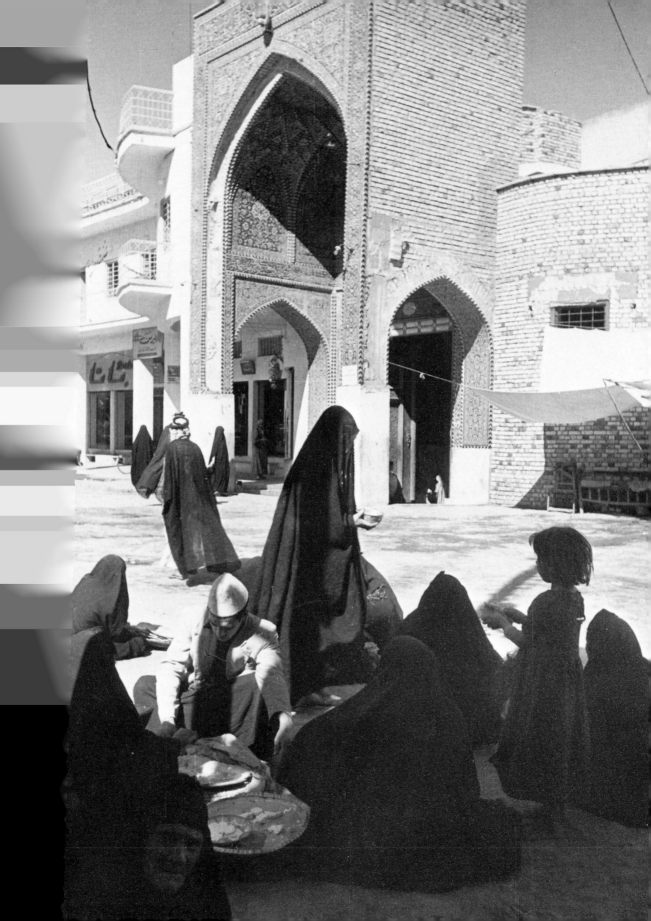

faces; the murmuring figures glide by like flowing water, paying scant attention to the anomaly of a European in their midst at this late hour. The extraordinary unity of Islam comes over me. These crowds are moving through all the cities of the East: from Morocco to Afghanistan, from Turkey to India and Java, they walk abroad through the nights of the Fast. In their shadows they are dim and unreal, less clear to the eye of the imagination than that Arabian Merchant who first set them in motion twelve centuries ago. How firmly he pressed his finger into the clay of the world! So that these sheep-like figures still obey, moving hither and thither in the night; and make one think, marvelling at its range of mediocrity and splendour, of the power of the mind and will of man.'

'Freya encountered a different sort of religiosity, darker, more strenuous and violent, at the Shi'ite holy cities of Najaf and Karbala south of Baghdad which she first visited in March 1930, undeterred by the Shi'ite reputation (then as now) for xenophobia and 'fanaticism'. She watched the processions of the Shia commemorating the death of Hussein, the Prophet Muhammad's grandson, killed in the dispute over the Caliphate in AD 682. Her words have a prophetic ring, written as they were some forty-five years before events in Iran turned the ritual Shia celebration of mourning into an unstoppable revolutionary flood:

'All through the ten days of 'Ashura, Shi'as in Islam mourn for the death of Hussein, until the slow, mounting tide of their grief reaches its climax with the last processions, and the slain body itself is carried under a blood-stained sheet through wailing crowds, where the red head-dress of the Sunni is well advised not to make itself conspicuous. All is represented, every incident of the fatal day of Kerbala; and the procession stops at intervals to act one episode or other in a little clearing of the crowd. One can hear it coming from far away by the thud of the beaters beating their naked chests, a mighty sound like the beating of carpets; or see the blood pour down the backs of those who acquire merit with flails ,made of knotted chains with which they lacerate their shoulders, bared for the purpose: and when the body itself comes, headless (the man's head is hidden in a box and a small boy with a fan walks beside it to prevent suffocation), its two feet sticking out of the bloody drapery, the truncated neck of a sheep protruding at the other end, a dagger cunningly stuck above each shoulder into the cloth – when this comes heaving through the crowd, there is such a passion of anger and sorrow, such a wailing of women from the roofs, such glances of repulsion towards the foreigner who happens to be looking on, that it is quite understandable that the civilized governments of the East are now doing all they can to discourage this expression of religion in favour of forms more liturgical.'

Opposite: 'You come in through mean and dirty suburbs, and then gradually through streets porticoed in a miserable way by crazy, palm-stem pillars, by cafés full of dingy seats and pale malarial faces, into the centre where the souks run in a shadowy circle round the mosque where the body of Hussein lies.' – The Shrine of Karbala, sacred to the Shia, Iraq, 1957.

Freya returned to Italy in the summer of 1933 by way of Amman, Petra and Jerusalem. She travelled third class on the boat to Trieste, sharing a cabin with six other women, many of them Jews from Germany or Russia, who kept being sick 'in the most unexpected places'. Arriving in Venice her suitcase rolled off the platform and under the train, which should have started some minutes before. She hesitated, but then thought of her eastern treasures, and she retrieved them from under the wheels 'thankful that the famous Fascist punctuality was now only a cliché of the British press'. Arriving in London, she enjoyed her first taste of public recognition. The Royal Geographical Society awarded her the Back Grant for her travels in Luristan, and the Royal Asiatic Society gave her the Burton Medal. She delivered public lectures, an experience she found thoroughly nerve-racking, lunched with the Allenbys, met Sir Ronald Storrs, St John Philby and Bertram Thomas. She was adopted by Sydney Cockerell, friend and literary executor of William Morris, Thomas Hardy and Wilfred Blunt. She signed her first contract, for *The Valley of the Assassins*, with the house of Murray, beginning a friendship with Jock Murray, and a publishing partnership, that would last a lifetime. It was thus with an 'established' reputation that she planned her next expedition, to the desert cities of South Arabia.

* * *

The Wadi Hadhramaut is a great valley more than seventy miles long and seven miles wide that runs from east to west, cutting into the high plateau or 'Jol' – some fifty miles north of the South Arabian coast and running roughly parallel to it. Once the centre of flourishing kingdoms based on the spice trade, it is abundantly supplied with wells and small oases. The most distinctive feature of the Hadhramaut and its tributary wadis are the tall walled cities of mud-brick houses whose double rows of windows give the impression of sky-scrapers drawn by children. Freya first caught sight of these exotic medieval Manhattans in a magazine article; her curiosity aroused, she read the accounts of the half-dozen European travellers who had been there, including the first of them, Von Wrede, who was lucky to escape with his life after being robbed of all his

Opposite above: 'This is the most surprising place to come across suddenly: it must have been incredible to the people who came upon it without knowing after riding through more or less desert for six days ... It is sliced down straight with palm trees, a river of palms at the bottom, square earth fields and white stream bed, and little towns growing out of the soil and the colour in clusters on either edge.' – Wadi Du'an, Hadhramaut, 1935.

Opposite below: 'The waterless road, the little fortress groups built with flat desert stones, the chaos of wild ravines uncontrolled by the hand of man and left to the impetuousness of geology.' – Wadi Azzan, South Arabia, 1938.

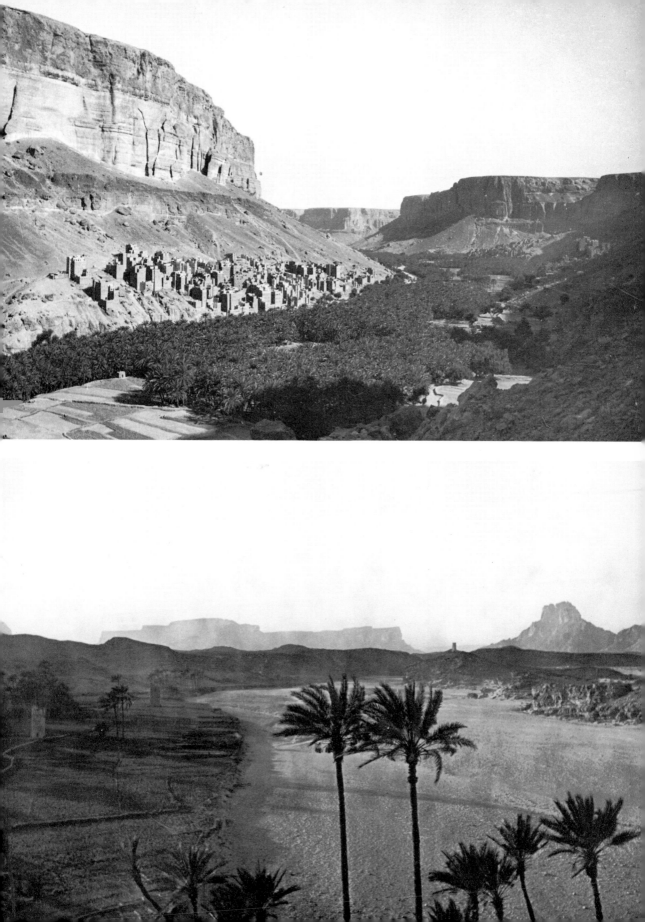

possessions in 1843. She read ancient accounts of the spice routes, first revealed by the Greek sailors at the beginning of the Christian era who discovered the secrets of the monsoon. But though both the Greeks and Romans forced their galleys into the perilous head-winds of the Red Sea, they never really succeeded in breaking the South Arabian monopoly on the spice trade. For centuries – indeed millennia – goods carried from India by slender, lateen-rigged dhows that hugged the coast during the monsoon season, were landed on the beaches near Cana and other South Arabian ports, to be carried by donkeys or camels through the narrow Hadhramaut valleys, arriving at Shabwah (the ancient Sabota which, according to Pliny, boasted sixty temples within its walls), before turning northwards by way of Najran and the holy city of Mecca (Ptolemy's Macorba) to the Mediterranean. Though the South Arabian civilizations declined, the traffic was never seriously disrupted, until the Portuguese opened up the Indian Ocean to much sturdier, European shipping. Indeed the wealth of Mecca, due to the Quraishite monopoly on that trade, helped fuel the Arab conquests that followed the coming of Islam. It was a section of this, 'once the richest and most rigidly guarded and perhaps the oldest of all the trade routes of the ancient world', that Freya now set out to investigate during the summer of 1934.

Her success in London had supplied her with good connections. She had introductions to Anton Besse, the French-born merchant who controlled the Red Sea traffic and whose empire – more like that of a Medici than a modern shipping tycoon – extended into the Hadhramaut valleys; and through Lord Halifax she obtained a letter of recommendation to the Governor of Mukalla, who controlled most of the coastal territory and about half the interior. The other half – in the North-eastern part of the Hadhramaut, was controlled by a rival sultanate and, until recently, warfare between the two great factions – led by the Qa'itis and the Kathiris – had been endemic, dividing the little city-states of the interior rather as the Guelph and Ghibelline factions had divided the Italian city-states in the late Middle Ages.

After spending a month with Anton Besse and his family in Aden, to familiarize herself with the southern dialects, Freya reached Mukalla in January 1935, having been landed there by one of Besse's dhows. She spent a week in the little port, with its tall slightly dilapidated houses piled under the red cliffs, arranging her journey and watching the Bedouin caravans. 'Fifty or sixty camels always there and always one long string leaving or arriving: always when you look at the sea you see some naked figure striding down to the water, beautifully made, his curly hair tied with a band round the forehead, his skin a dark ebony brown: the way these people move is simply a delight to watch.' She found a couple of tribesmen ('two little wild creatures of some earlier world than ours')

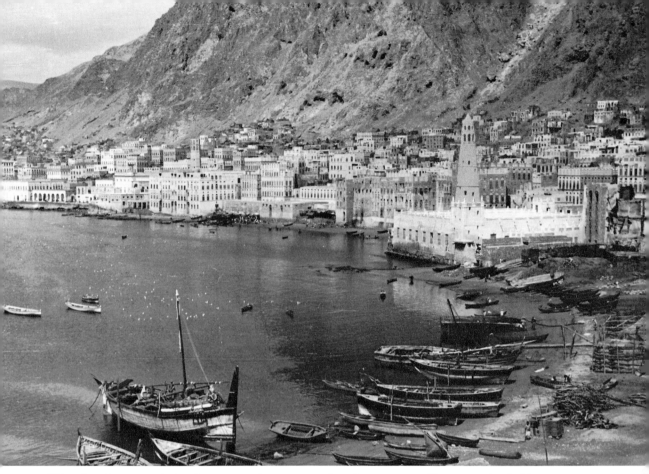

'The view from my window is as romantic as you can imagine: a sweep of bay, a patch of white sand-dunes huddled the rock by the monsoon, and hills and hills and hills. The sunset catches the ripples of the bay and loses itself among these ranges: a little straw village in the foreground with a small white mosque and square minaret like a village church in England.' – Mukalla, South Arabia, 1935.

to take her with four donkeys across the plateau or 'Jol' to the Wadi Du'an and onward to Shibam in the Hadhramaut, northernmost limit of the Sultan of Mukalla's authority. From here she intended to journey to Shabwah, about sixty miles to the west on the edge of the Imam of Yemen's territory; and thence by way of the Ma'rib dam (the collapse of which, shortly before the coming of Islam, signalled the final decay of South Arabian civilization), north-wards as far as Najran. If this proved impossible, she intended to return from Shabwah to the coast at Bir Ali – near the site of the ancient spice-port of Cana.

In the event her plans were thwarted, once again, by illness. The party, now expanded by the addition of one of the sultan's bodyguards, a Bedouin flautist and two extra donkeys, set off on 21 January 1935; their supplies, in addition to coffee and rice, included several live chickens, to be consumed *en route*. They

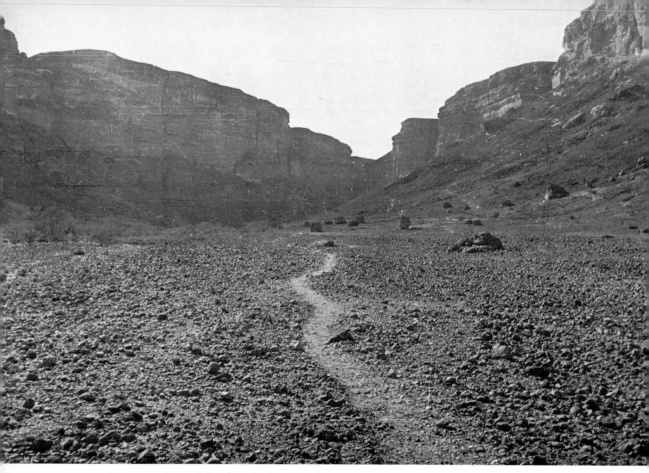

'... up and up, following the length of the wadi ... and changing temperature every day – following as it were the work of water through millions of years, for when one comes into these landscapes one is brought face to face with the history of the earth – and what a ravaged history ... how much too big for the human this immensity is ...' – Near Huraydah, 1938.

walked up the Wadi Himem – 'following, as it were, the work of water through millions of years' – the arid immensity of the landscape only occasionally relieved by small oases with palms and fields of maize. They climbed to the Jol, a landscape which 'gives one the feeling of being an insect running along till some huge crack in the world's surface stops it'. After six days, they came to the first of these 'cracks', the narrow Wadi Du'an running northwards into the Hadhramaut. They arrived at Masna'a, the first of the little medieval walled towns; and it was here that disaster struck, though Freya would not feel the effects at once. Invited to take a meal with the women in the Governor's house,

Opposite: '... the bottom storey of the house is unprovided with windows from motives of defence. It is usually filled with goats or donkeys, and branches into turns and stairs as puzzling as a labyrinth, until ... one comes ... to the various apartments, each provided with sanitary arrangements of its own that drain by a wide shaft to whatever street happens to be below.' – Khuraybah, 1935.

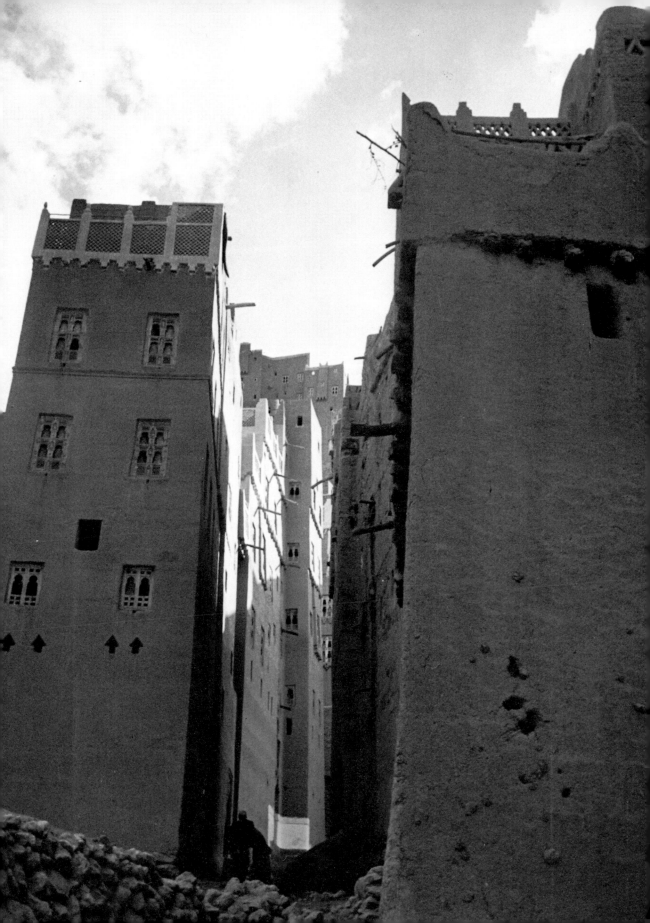

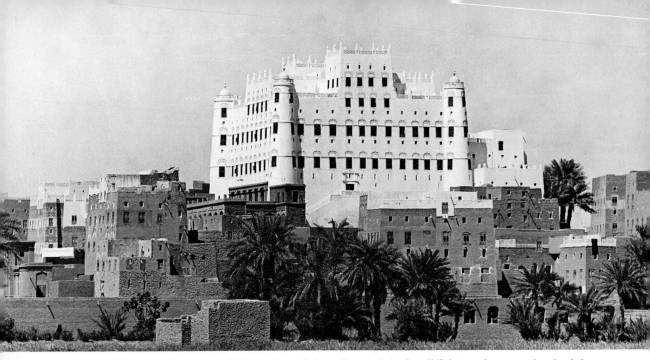

'We crossed to the south bank where Seiyun lies against the cliff, its gardens running back into a side wadi and out into the plain. In its middle is the palace of Sultan Ali, a tower-square painted white and jade-green ... It is wonderful to be going into towns *purely* Arab – no tourist touch, a world left over and where the West only comes by Arab ways. And with it all, the feeling of prosperity, the beautiful green of palm-gardens full of birds.' – Seiyun (now spelled as Saywun), 1935.

she shared with her hosts a plate of *harisa*, a dish of 'meat and flour like porridge, with a cup of melted butter in the middle – very good'. But one of the children had measles – and there were no doctors – 'everything, they say, is done by God'. Freya, who had thought she was immune, caught the disease, and developed a high fever. The women looked after her as one of their own, in a room beset with the constant comings and goings of children. They refused to let her wash, believing it would be bad for the sickness. After about a week Freya seemed to recover, and the party moved on to Hajarayn and Meshed. In Hajarayn, she was cheerfully told, twenty-five people had died in the measles epidemic. Hoping to explore the great Wadi Hadhramaut before heading for Shabwah, they turned east by way of Al Qatn, where the sultan lent them a car, and then they drove to Shibam, largest of the Hadhrami towns, where the RAF had a landing-ground. From there they drove to Saywun and the ancient city of Tarim in the Kathiri territories, at the invitation of the local dignitaries.

Opposite: 'I drove round the town: it is grimmer than Seiyun, the old houses more like forts, but all this fortress look is diluted by sudden casino intrusions from Java, so that on the whole there is not the charm of Seiyun, which is still pure medieval Arabic.' – Tarim, 1935.

56

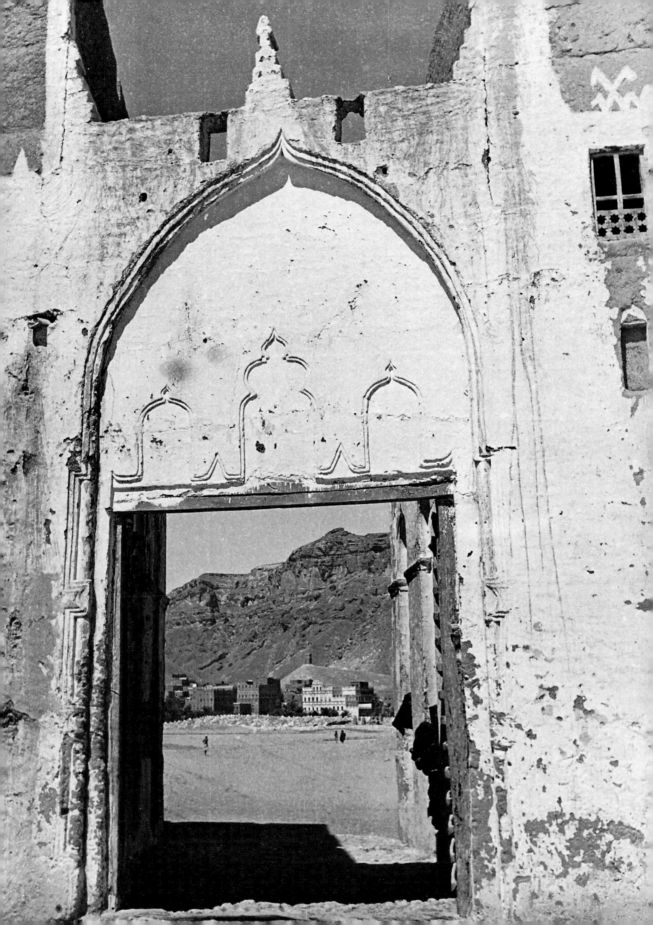

'Today we had a great ceremony, as the intelligentsia of Tarim were invited to meet me in Sayid Omar's house: I walked in and shook hands all round ... and, when we had talked about the Education of Women and suchlike elevating topics, a little man got up and made me a really excellent speech in beautiful Arabic to welcome me as the first woman who came here alone purely for the love of learning.' – Interior, Tarim, 1935.

Then, returning to the head of the Wadi Du'an, she made for Huraydah in the Wadi Amd, to wait for a caravan to take her on to Shabwah. But there she became seriously ill, with what she thought was malaria, but which turned out to be a complication of the measles. She was taken into a harem in Shibam, under the care of two local sayyids (religious noblemen). As in Alamut four years before, she hovered on the edge of death: 'I was losing my strength. I

Opposite: '... I went to call on the harem which is all Javanese, pleasant but not nearly so nice as the Arab, and all their mouths horrid with betel nut ... There are lots of Java women here, as everyone who goes to Java has a second family there and eventually brings it home.' – Tarim, 1935.

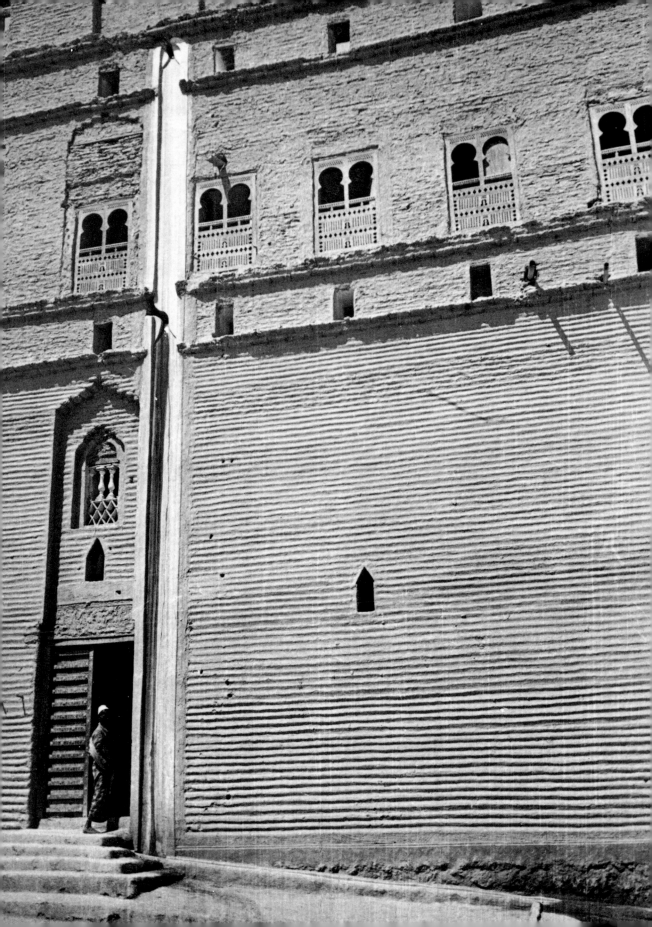

could not see my watch, but listened to a tiny pulse in my ear like a wave breaking on some unmapped shore, and waited for it to cease; when it did so I should be no longer there to know.'

She taught a servant to inject her with coramine, a very painful performance, which he enjoyed, since it made him feel like a doctor; but she would certainly have died had it not been for a chemist from Tarim, trained in Malaya, who brought her some new medicines. A message was sent to Aden, and soon an RAF bomber arrived which flew her to hospital: but not before she had learned the painful news that a young German photographer, who had made himself notorious in the area by publishing false tales of cannibalism and prostitution, had reached the elusive Shabwah.

Freya returned to the Hadhramaut in the winter of 1937–8, on an expedition that was to prove almost as disastrous, though in a different way. She was invited to dig at Meshed with Gertrude Caton Thompson, an archaeologist of some standing. Freya had shown Miss Thompson some obsidian fragments from Meshed, which interested the latter enough for her to organize an expedition.

Between them the two women managed to raise the money from the Royal Geographical Society and private subscribers, including Lord Wakefield, a friend of the Ker family, who presented Freya with a cheque for £1500. In October 1937 Freya joined Gertrude Thompson and Elinor Gardiner, a geologist, on board the SS *Narkhunda* at Port Said. A frostiness seems to have entered the atmosphere immediately. Freya found Miss Thompson, whom she regarded as a typical, somewhat stuffy 'blue-stocking', dull to talk to, and probably felt that Miss Thompson disapproved of her amateur enthusiasms and lack of formal qualifications. Once installed at Huraydah, where they rented a house, matters went from bad to worse. Freya's job in the expedition was to handle relations with the local people, allowing the scientists to go about their business without interruptions. But in the Hadhramaut, matters could not be arranged so easily. On her previous journey Freya – with her good Arabic, her tact, her patience and knowledge of local customs – had always been an object of curiosity, surrounded by crowds of people and children as strangers always are in the traditional parts of the East. The presence of three *Feringhee* women, with their quantities of equipment, almost caused a riot. Gertrude requested Freya to 'arrange things rather better, so as not to have a crowd'. Freya explained that one cannot have the Hadhramaut without its inhabitants, 'nor can one shoo these people away and still be welcome among them: the very corner-stone of their democracy is a general accessibility'. Matters became worse when, tactlessly pushing a labourer aside in order to examine a find, Gertrude caused a fight to break out, ending with one man seriously injured.

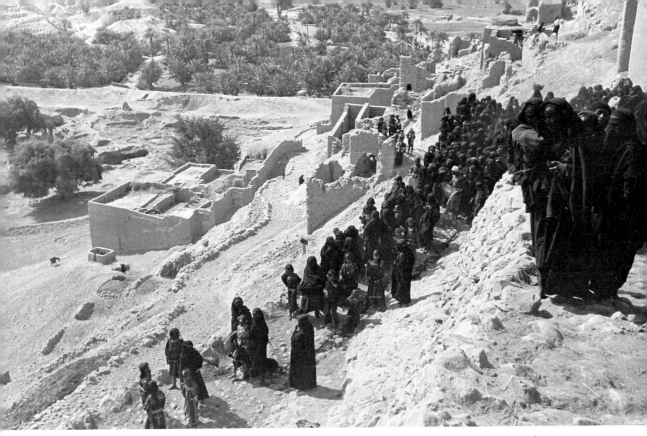

'It was great fun to look down on it all – the crowd incredibly picturesque with blue, green and every shade of yellow and orange women's gowns, the little sparkling trains, beads and girdles of the little girls, the negroes and dark Hadhramis, the Bedouin with gowns here and there.' – Tarim wedding, 1935.

The argument was more than just a clash of personalities between two powerful women, each wanting to be boss. For Freya it entailed fundamental questions of principle – even of philosophies of life. She perceived in Gertrude's single-minded pursuit of knowledge – to the exclusion of other human considerations – an example of materialist arrogance, the triumph of Science over Art.

Leaving the others to return by car, Freya decided to make her way by camel along the southern end of the ancient spice route, through the Wadi Amd to the coast at Cana, modern Bir Ali. Accompanied by Sayyid Ali, her guide, and Qasim the cook, she passed through the Wadi Amd, a secluded valley 'remote and self-sufficing, where travellers alone bring news of the world outside'. The people were among the ugliest she had encountered, with huge mouths, bony faces, and eyes rather close together. At the town of Zahir she felt sick again, but recovered enough to resume her journey through the Wadi Shi'be, a narrow valley of scattered villages never before visited by Europeans. Then they passed over the plateau to the oasis of Ye'beth, where forts and houses spread out in

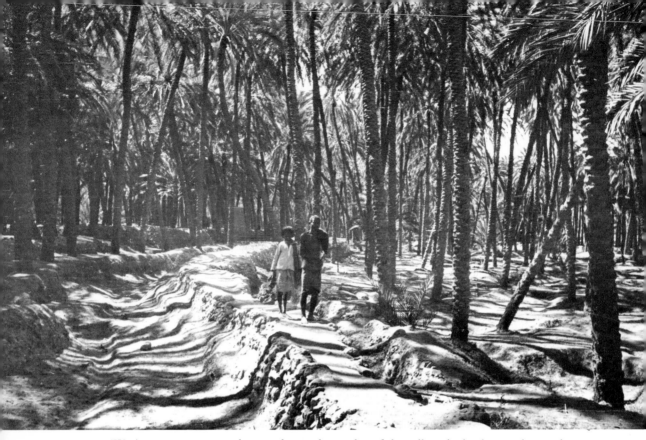

'We began to come to palms on the southern edge of the valley: the landscape changes because here the water is brought up from wells . . .' – Palm groves at Wadi Du'an, 1935.

groups among dusty gardens and palm groves. At Naqb al Hajr she was entertained by the Sultans of 'Azzan, anxious to show her off as proof of the friendship they enjoyed with the British, for this was outside the area of the tribal peace currently being constructed by Harold Ingrams, the British Resident in Mukalla. Here she joined a caravan of twenty-seven camels, and was able to admire the way in which the Bedouin had evolved material possessions suitable for their style of life:

'One after one all my modern gadgets failed me; the thermos broke, the lunch basket was far too complicated, only the Mansab's quilt stood me in good stead. But the bedu's waterskin, with one hand used as a cup and a funnel, is economical and light; his coffee-pot, brass and unbreakable, hangs under the saddle over the camel's tail; his cotton shawl can be used for everything in the world that cloth is ever used for. He has all that is necessary and nothing superfluous; and if his rope were of the kind that did not break whenever you pull at it, one might say that his equipment was perfect of its kind.'

In a few days they reached the sea, and headed east for Bir Ali, trudging, exhausted, by night through a desolate landscape of grim, volcanic shapes

silhouetted against the sky. Here she eventually picked up a dhow which brought her, exhausted, back to Aden.

The story of this journey, and of the disastrous dig with Gertrude, was recorded in Freya's second South Arabian travel book, *A Winter in Arabia*. Against the advice of friends, she gave a candid – perhaps too candid – account of her conflict with the archaeologist. Hers was, no doubt, a highly subjective judgement. But the row, as well as revealing something about Freya's personality (a jealous and possessive streak had remained with her from childhood, and it is easy to see how crushed poor Vera must have been by her sister's overbearing will-to-power), also brought out her peculiar strengths as a traveller and writer.

Freya's hostility to Gertrude and 'Science' – whether justified or not – flowed directly from her sympathies with the people among whom she travelled. She felt that the archaeologists were exploiting the people of the valley, by the sheer fact of giving the pursuit of their own specialized knowledge priority over everything else. As a traveller her approach had been exactly the opposite. Unlike such typically masculine adventurers as Burton and Philby, who were willing to subordinate everything and everybody in order to achieve their objectives (whether discovering the great lakes of Central Africa, penetrating Mecca or crossing the Empty Quarter), the ultimate goal for Freya was far less important than the journey itself. Her finest travel book – *The Southern Gates*

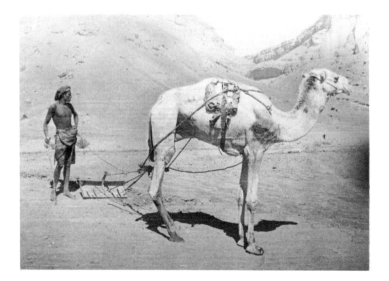

'No animal seems so rock-like and permanent as a camel in its own landscape. I can see why the bedu love the camels: they are always so obliging, always ready to do what *you* want and not what *they* want – so unlike donkeys.' – Ploughing in Huraydah, 1938.

of Arabia – is the story of failure: she never reached Shabwah and never succeeded in following the incense trail beyond regions already explored by other travellers. What she achieved and recorded is unforgettable, not because of the places she saw and described, which had been seen and described before, if never so elegantly, but the people she encountered on her way. She had an artist's eye for details of manner and dress, and a novelist's ear for dialogue. She not only relished these encounters with people; she was able to participate in their wants, their needs, their travails and joys to such an extent that she identified with them rather than with her fellow Europeans. This was not so much 'going native' in the pursuit of power or glory, or self-extinction, in the paradoxical fashion of T. E. Lawrence and other travellers in the East, like Palgrave and Blunt; it was rather a matter of enjoying people as she found them, and for what she found in them. Freya was anything but a social misfit. Throughout her life she remained highly gregarious, and an excellent practitioner of one of the skills she valued most highly – the art of conversation.

Her attitude towards the people among whom she moved was the opposite of imperialist. Where the average European was mistrustful or suspicious of natives, Freya had an almost naive belief in human goodness and natural honesty. In Baghdad she came close to the ordinary people because, knowing her to be poor like themselves, they were not made to feel inferior. 'The nicest way to know people', she wrote to her father, 'is not to be important or wealthy.' In South Arabia she learned very quickly that the worst thing a traveller can do is to scatter money about: 'We insult and corrupt people by treating their goodness as if it could be paid for ... Nothing is more subtly insulting than to refuse to be under an obligation.' As a pilgrim or supplicant, Freya understood that – as most foreigners, especially English people, for whom it is a point of honour to 'pay one's way', usually fail to understand – one brought out the best in people, and this was the surest guarantee of protection. In Huraydah she entrusted her money to the safekeeping of her cook – in marked contrast to Gertrude, who insisted on having a useless 'European' lock fitted to her bedroom door, and predictably had all her dollars stolen. When Freya did lose one of her rings, she cleverly engineered its return by threatening the thief with divine exposure by means of a potion containing a fragment of the Quran.

In acquiring protection, her position as a woman was generally an advantage. In most tribal societies it is considered dishonourable to attack women, since warfare is an exclusively male preserve; and patriarchy, especially in the purer forms encountered in the Muslim world, usually allows for exceptions. 'The great and almost only comfort about being a woman', she observed sardonically in her account of Luristan, 'is that one can always pretend to be more stupid than one is and no one is surprised.' In South Arabia, however, the advantages

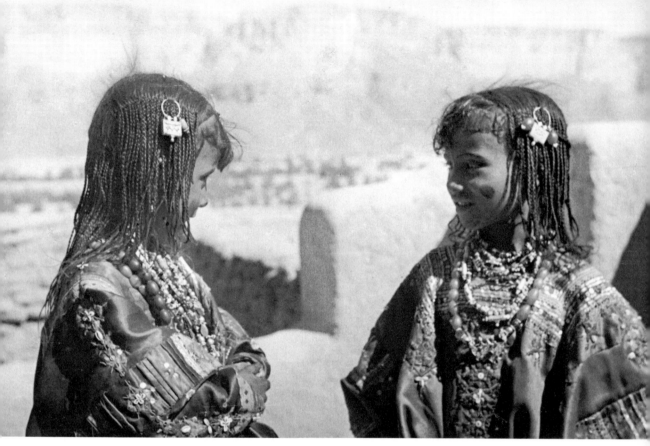

'We went home for a rest before the labours of the afternoon when the little girls were to come and dance for me. They came in relays with a swishing of anklets and bells all afternoon, ever so anxious to be photographed ... their faces are still decorated with green and brown and sometimes red.' – Hadhrami girls, Huraydah, 1938.

of being female extended far beyond the assumption of stupidity, however convenient. Her unmarried status, so exceptional even in a *Feringhee* woman, seems to have conferred upon her a kind of *baraka* or blessing, such as Islam often allows to individuals whose behaviour is so unusual that it can be only explained as a product of divine dispensation. 'How happy you are unmarried,' the sister of a tribal chieftain told her, 'Allah alone is above you.' At Huraydah her prestige was such that odes were composed in her honour:

'Faraya outstrips in excellence the most intelligent of women:
By her learning and her breeding she is uplifted beyond Ranees.
She comes to all with gladness, and may the clearness of her face never be saddened:
With beauty of thought and manners she conquers men and women.'

Freya's status as a *Feringhee*, capable of disposing of European power and prestige, gave her access to the sultans whose honour it became to protect her. Her sex gave her access to the harems, a closed, protected world where only

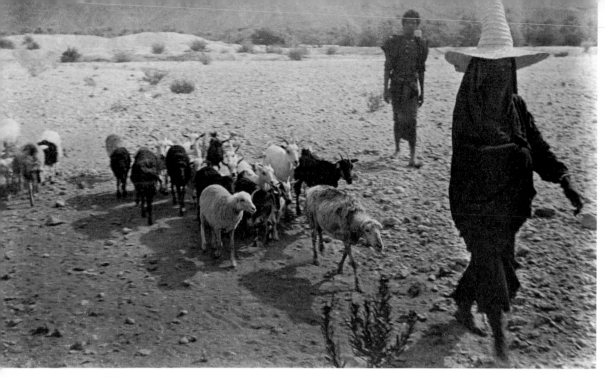

'Slender shepherdesses were all about the landscape ... it was amusing to see them so active, wound in draperies with faces hidden by black veils.' – Shepherdess, Huraydah, 1938.

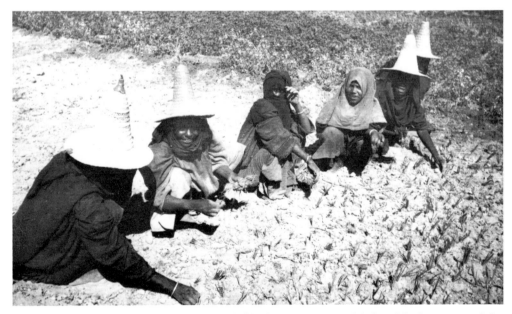

'We called the shepherdesses in their witch-like hats to come and help with the names of the flowers. The shepherdesses know them, and know their uses, and which are liked by camels and which by goats.' – Palm planting in the Hadhramaut, 1935.

the women, or their male relatives, could venture. Thus doubly privileged, she saw, and experienced, both sides of the sexual barrier: the courtesy and gravitas of men, the gaiety and calm of women:

'The faces of the men are often spoiled by theology, or by being puckered for years in the sun; but the women keep into old age an expression of calmness and sweetness, and the lines that are common in Europe are hardly to be found in these harems. This comes, I think, because living always together and under a rigid code of courtesy, the feelings which create these lines are never allowed free play. Better than self-control, they have that true serenity that begins at the very source, eliminating the feelings for which self-control is required.'

These are not, however, mere happy peasants, viewed according to some sentimental idea of pastoral innocence. She saw, and experienced, the hardship of the lives affecting these communities – the death and sickness of infants, the threat of disease, the flies, the raw sewage in the streets, the endemic violence of tribal warfare, the permanent condition of human insecurity; as she wrote, years later in her autobiography:

'What has chiefly remained for me apart from the beauty of the valley-pictures that lie deep in my mind, is the *intimacy* with a world so strange and remote: it amounts almost to an annihilation of time, for the then scarcely visited smaller valleys of the Hadhramaut seem to be separated by centuries rather than space from the life of Europe ... the history of the Middle or even the Dark Ages will never be mere history to me, since I have lived it and know what it has been ... Its difference from our world went far deeper than mere circumstance: it went beyond its permanent insecurity, which is now no longer a stranger in Europe: it was perhaps an *acceptance* of insecurity as the foundation of life. This gave to everything, even to very small things, a significance, a sharper outline as it were, such as you may find in Gothic carving or Elizabethan writing: the whole landscape is illuminated by an eternal light.'

It was this world of dark shadows and brilliant sunlight, sinuous limbs and flowing draperies that she portrayed in her two books on the Hadhramaut. The exotic landscape, the fantastic architecture, are always present: but it is the people in the foreground who first command one's attention. They are observed, and depicted, with an unusual sympathy which combines affection and detachment, rather in the manner of the best novelists. It is perhaps not incidental that Freya often took Jane Austen, along with Virgil, on her travels. But unlike the novelist, Freya was also an actor in her drama, as well as being the vehicle of her own impressions.

In a sense, all travel writers are novelists, with themselves as heroes. The *persona* of the traveller, the figure with whom the reader identifies, is necessary to the genre. In her early books the *persona* portrayed by Freya is especially

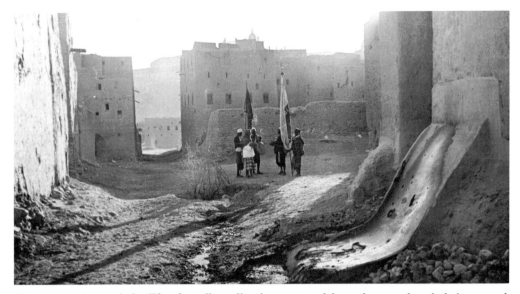

'One can understand the life of small medieval towns, and how they produced their art and brought out all that was in their people, combining so strong a commercial life with one so independent of all outside . . .' – Medieval sewage system, Huraydah, 1938.

sympathetic. She is full of pluck, but intensely vulnerable. She triumphs over obstacles, both physical and human, only to be floored by disaster or illness. She endures her sufferings and frustrations with a good-humoured stoicism she did not always show when faced with minor tribulations in later, more celebrated, years. She is alert to what is comical and absurd in her human surroundings, which she occasionally illuminates with pleasing shafts of malice. Thus on her first journey to the Hadhramaut, she conspires with her Bedouin guide against the simple-minded soldier whom the Governor has sent to accompany them: 'Said looked at me. I smiled. He smiled. Without a word we consigned our protector to the limbo of the imbeciles where he belonged, and returned to talk of reasonable things like tribal wars.' While trying to take a photograph, she avoids a potentially ugly scene by turning the tables on a vociferous tribeswoman who, from the safety of a wadi, shrilly berates her menfolk for allowing an Unbeliever to take pictures of their land:

'"One thing", I remarked, "is ever the same in your land as in mine."
"And what is that?" said they.
"The excessive talk of women." The delighted audience rushed to shout this remark down with embellishments, and with a last vindictive snap, the female voice was silent.'

The reader cannot but delight in the way she scores points against local bullies or tribal bores, a sharp-tongued Emma speaking in Arabic. The degree of

veracity in these anecdotes hardly matters – was it really like that? or is there more than a trace of *l'esprit de l'escalier* – that perfect remark thought up *after* one makes one's exit? But who really cares? It makes for good reading, and the picture, real or partly fictional, of the Englishwoman who enters so perfectly into an alien culture that she survives by sheer force of wit, is utterly seductive. And just as these highlights sparkle, so are the shadows sombre. Her sicknesses, real, imagined, or what is perhaps more likely, dramatically enhanced, place her at the mercy of medieval remedies, opening the gates of compassion. For the European, accustomed to exercising power, it is more difficult to receive than to give: understanding this, she reveals all that is best of the people among whom she travels, demonstrating how charity, kindness and hospitality are second nature to them.

Did Freya idealize her Arabs? Like Doughty, by travelling alone and relying on the hospitality of the desert, she brought out what was best in their traditions; and like Doughty, she attributed their virtues to a common feeling with which she could identify. In Doughty's vision, the true source of Bedouin hospitality was Divine Grace: 'They see but the indigence of the open soil about, full of dangers, and hardly sustaining them, and the firmament above them, habitation of the Divine Salvation.' For Freya, that special grace was the condition of the Bedouin's freedom, his commitment to 'an immaterial set of values'. 'Poor as his best may be, he can follow it when he sees it, and that is freedom. We, too often compelled to see two roads and take the worst one, are by that fact enslaved ... the second best for security in finance, the second best for stability in marriage, the second best for conformity in thought ... It would be pleasant, I reflected, to look back on a life that has never given its soul for money, its time to a purpose not believed in, its body to anything but love. The Arab can still say this, unconscious of alternatives.' Both statements probably tell us more about their authors than their subjects. But there remains a generosity behind this vision, a willingness to project on to the human landscape an image of one's own aspiration, one that enlarges rather than diminishes, and is therefore the opposite of patronizing. Like those depicted by the Venetian painters she knew from childhood, hers was a landscape 'transfigured by love'.

·3·
THE ART OF PERSUASION

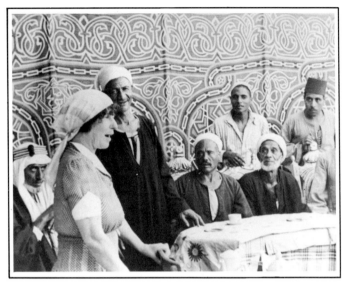

'YOU CANNOT THINK how pleasant it is to live in a country with a sensible dictator,' Freya had written from l'Arma in 1923. 'The Greeks may not like it, but here the railways improve, the post office works, the laws are beginning to be observed.' Freya was not the first English person to welcome Fascism in the twenties, and though she eventually became bitterly hostile towards it, her disillusionment was not sudden. Her later disenchantment may not have been unconnected with the fact that Mario had become head of the Fascists in his district, a position which she thought would strengthen his hand in the lawsuit. But even after local acts of thuggery by Fascist *squadri* had enraged her, a visit to the island of Rhodes on her way to the Levant convinced her that the Fascist form of government was best for a 'primitive and ignorant population. How much better than our foolish talk of liberty for the natives

Opposite: '... as soon as we got inland on the plateau, we came to the desert track of the armies, that vast battlefield. For over 300 miles one is *never* out of sight of some derelict tank, lorry, armoured car or gun; they lie around in every state of demolition or disintegration.' – Qasr Shahab, Libya, 1950.

Above: 'Propaganda ... should depend for its efficacy and dissemination entirely on personal influences, so following a tradition which many centuries of history have made familiar and well adapted to the East.' – Freya addressing a group of Brothers in Cairo, 1940.

71

before they have learnt the rudiments of it.' Freya was just as impressed, in the early days, by Hitler. 'I must say I would be an ardent Hitlerite if I were German,' she wrote from Bavaria in 1934. 'There is a general feeling of youth and vigour, for which I imagine the new regime must be given credit.'

Fascism seems to have appealed to an authoritarian streak in Freya's character, revealed in her sometimes imperious dealings with people she regarded as her social or intellectual inferiors. Usually, however, her intelligence, and sensitivity to people, got the better of her. What finally turned her against Fascism were accounts, from Somalis in Aden, of how Italians in Somaliland obliged the natives to salute every European they passed and even to get off the pavements. Imperialist she may have been, but she was never a racist. It made her sick to watch Britain and France giving way to Italy over Abyssinia. In the Hadhramaut she encountered generalized anti-colonial sentiments, the feeling that 'Europeans were looked upon en masse as people entirely bent on their own interests, out to exploit the native everywhere'. She felt so strongly about the damage this was doing to British interests that she wrote to Lord Halifax (later to become Chamberlain's Foreign Secretary) telling him 'how far-sighted it would be', from the point of view of Britain's position in Asia, 'if we would stop this crime: it would turn us at once from one of the "oppressors" into an ally of the "oppressed", and do away with a picture of the British that has been spread everywhere in the Middle East by the modern literature of Egypt and Moslem feeling over Palestine'.

Having turned against Fascism, she came to the conclusion earlier than many, that war with Italy was inevitable. This pained her a great deal. She had Italian nephews and nieces and looked upon Italy as her homeland. She knew that her mother's sympathies lay with the Fascists, who had commended her efforts to revive Italian handicrafts. In 1938, the year of Munich, she took Flora to Greece, accompanied by her pet lizard Himyar, named after the tribe of the Bedouin who had given it to her. Jock Murray joined them for the visit to Delphi, where Himyar promptly got lost under a ruined temple. He was recovered, only to succumb to the cold of England a few months later, despite expert advice from Julian Huxley about his diet – 'I think he and I were alike in lots of ways,' she told her mother, 'both rather small and lonely in our hearts. It may be ridiculous to care so much, but after all there is less difference between us and a lizard and us and God, and we expect *Him* to feel an interest.'

Afterwards, she returned to Bavaria for a cure, with mountain walks and visits to the opera. Coming before a group of Germans who were contemplating a crucifix at a wayside shrine, she could not resist remarking in German, 'It's a remarkable fact that He was a Jew.' A silence surrounded her and when she turned round the whole group had disappeared.

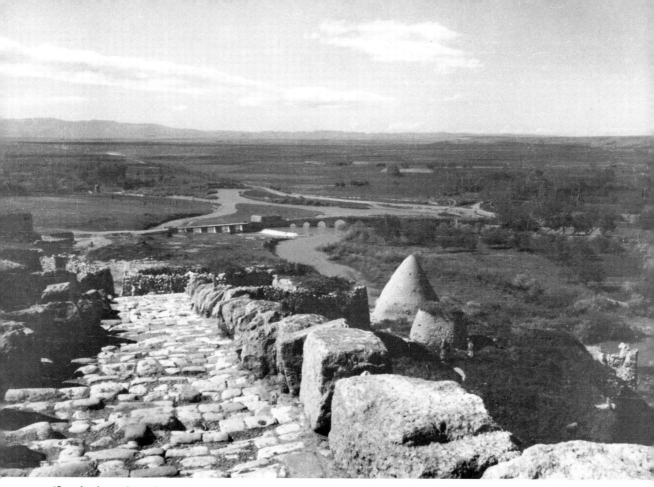

'I rode down into the valley of the Orontes, one of the loveliest things in this world to do. It is so unhealthy that very few people live there, but the corn and meadows are rich and green, and the flocks pasture in the solitude of cities long dead. It has just been for many centuries a passageway for armies.' – The Orontes near Sheizar, Syria, 1939.

Early in 1939, Freya wrote to the Foreign Office offering her services in the event of war. She was told to present herself in London or Cairo when the crisis finally came. She made a short journey to the Levant, visiting castles in Syria, before returning to Asolo, where she spent a week with her mother and Herbert Young, now 84 but looking strong and healthy. She arranged their affairs in Italy – packing the most valuable things and distributing them among friends for safety. She arrived in London six days before the war broke out. Within a month she had been posted to Aden as an Arabist attached to the Ministry of Information. With Italy still neutral, she sailed from Venice, where she saw her mother and Herbert Young for what proved to be the last time.

It was a happy time for Freya, despite the anxieties she felt about her mother in Italy. Her chief, Stewart Perowne, whom she had met and liked on her previous visit, and whom she would later (disastrously, as it turned out) marry,

73

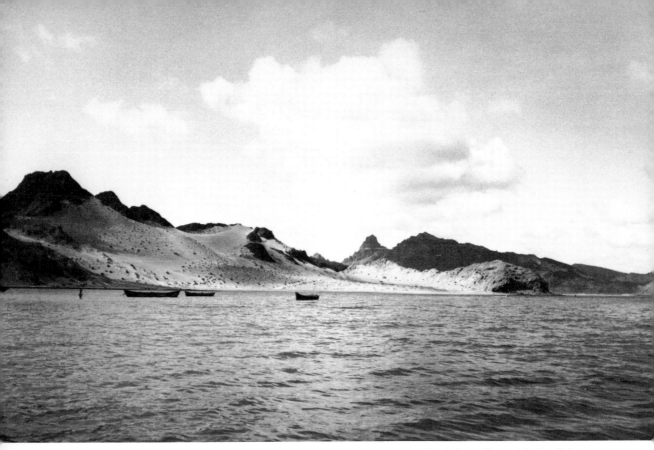

'... the sea heaves with the sweep of the coast past the mouth of Aden Bay with flat lights on it as it catches the west. And half bathed in the light, half black in their own volcanic shadows, the rocks of Aden stand up like Dolomites, so jagged and old.' – Aden, 1934.

was a scholar and classicist who wrote several distinguished books on Roman history. She described him (with a naive enthusiasm) as 'gay, slim, well-dressed, enthusiastic, with a sparkle that matched the sunlight on the bay'. Knowing that Italy would eventually enter the war, she convinced Stewart and the Governor, Sir Bernard Reilly, to send her to San'a, the capital of Yemen, to counter Fascist influence. She performed her task so successfully that – much to Stewart's chagrin – she was soon promoted to undertake similar work in Egypt.

The ancient kingdom of Yemen was at that time among the most isolated in the world. Once the seat of a flourishing empire – the *Arabia Felix* of the Romans – it had maintained its distinctiveness after the coming of Islam by adopting a version of the Shia allegiance known as Zaidism. The Imam Yahya, who had thrown out the Ottoman Turks from his country before the First World War, was an autocrat, both spiritual and secular, who ruled his country with an iron hand. Legend has it that he would sleep with a rope tied tightly round his neck, to encourage his eyes to stick out, thereby enhancing his already

fearsome appearance. In fact, moral suasion, rather than physical force, helped keep his unruly tribesmen together. His armaments were negligible – a few battered rifles with, perhaps, the odd howitzer, until Mussolini obligingly provided him with some modern artillery which the Imam placed provocatively near his frontier with the Aden protectorate. Embroiled as he was, in border disputes with the Saudis in the north and the British protectorate in the South, it is not perhaps surprising that he looked to the Italians for assistance. But he also mistrusted them. Mussolini had made the gaffe of trying to land troops at Hodeida, the main Yemeni port on the Red Sea. He had been thwarted only by the presence of mind of the commander of a British sloop. Thereafter the Italians concentrated their strategy on diplomacy and influence. They paid handsome retainers to princes and ministers, and placed doctors, with paramilitary technicians, at strategic points in the interior.

Freya arrived in San'a early in February 1940 after a tortuous six-day journey by truck over 'what nobody in England would call a road'. This time she travelled, Gertrude Bell-style, with an entourage consisting of a cook, a personal servant and three other men. The country through which they passed, with long rolling plains and blue-tumbled hills, was 'too beautiful for words'. San'a was a completely medieval city of tall mud-brick houses, where the gates were firmly closed after dark. The Imam had two palaces, one for each of his wives, with a garden between them. His sanctity was such that he would not meet Freya, an infidel and a woman, directly. But he gave orders for her to be treated hospitably.

As an employee of the British Ministry of Information, it would have been appropriate for Freya to have been received by the Minister of Education. The man in question, however (without, apparently, being removed from office), was languishing in one of the Imam's dungeons. But she was courteously received by the Foreign Minister and his wife, who had both seen the outside world, having once been posted to Istanbul. Knowing how powerful the influence of women can be in a closely segregated society, she decided to concentrate on the Foreign Minister's wife, with a view to getting her message across in the harems.

Apart from her Arabic which tended to conquer all doubts at the numerous ladies' tea parties she attended, Freya held a trump card with which to trounce the Italians. She had smuggled in a portable cinema projector among her baggage. This object, of course, was an invention of infidels strictly forbidden on religious grounds. At first Freya merely described it to the Foreign Minister's wife: she would not dream of showing it without the Imam's permission. Within a few days a private showing had been arranged at the minister's house, attended by one of the princes. The films – standard Ministry of Information

stuff about the Royal Navy – made a tremendous impression. Prince Qasim talked about the 'rule of the waves' for the rest of the evening. 'Do not the Italians rule the Mediterranean?' he asked. Freya replied, 'You would hardly call yourself a ruler in a house where someone else has both the front and back door keys.' The ladies from the Imam's palaces demanded to see the film. A showing was arranged at one of the palaces. More films were produced – Holyrood House, schools for aerobatics, the miracle of modern medicine. Determined to find out if the Imam was seeing the films, Freya deliberately blundered into the masculine half of the audience. Sure enough, there he was sitting, surrounded by his sons. She only glimpsed him for a moment – 'they screened the horrid apparition away from him so soon'. The Italians were livid. They talked of bringing in a projector of their own; but as it had taken them months to get permission for a gramophone, their chances seemed slim.

In her conversations, Freya appealed openly to Yemeni pride, even snobbery. The society was strictly hierarchical, with social divisions reinforced by inherited sanctity and religious learning. She knew the Yemenis felt insulted by the Italian practice of bribing them – though they would not, of course, refuse the money. 'The fact that Hitler was a paperhanger, and Mussolini's father a blacksmith,' she told Stewart Perowne, 'carries an unexpected weight.' Within two weeks of her arrival, it was clear that she was turning the tables on the Italians. When told by her servant Nagy (who relayed the talk from the souq) that the Italian colony disliked her, she wrote disingenuously, 'I can't think why. I do nothing but say all round how sorry I am for them all.'

By the time Italy finally entered the war in June, Freya was back in Aden. The first British guns were fired while she was dining with Harold Ingrams. They watched the air-raid from his roof: '. . . eight beams of searchlight, and where they met, shining yellow in the moonlight, the little cross of the aeroplane . . . From behind the Crater ball after ball was sent into the sky in long strips, like soap bubbles. It was all dream-like and incredibly beautiful, so that one could think of nothing but that rapture of loveliness so near to death.' The next raid caught her out riding. She took refuge in a village police post 'among Arabs, who take such things with perfect calm, only interrupted by delight when we seemed to register a shot'. She was annoyed when Stewart forbade her to go out riding again. 'I feel that every little crumb of beauty, every bit of normal, pleasant life must now be saved up,' she wrote to Sydney Cockerell. 'One enjoys it more than ever in this black contrast, and perhaps that heightened sensitiveness is the greatest compensation in war.'

There were other compensations too. Friendship with Stewart (she was pleased when someone – a hospital nurse – remarked how alike they were), who treated her 'like a wife' expecting her to be there without being told the full

'A cool north breeze blows through [my flat] from the lesser Nile and the slow barges filled with straw or cotton or bricks come sailing by, their masts taller than the landscape of houses and distant palms behind them.' – Cairo, 1940.

programme ('I keep him', she wrote to Cockerell, 'in a state of mild but continuous exasperation: do you think this is a sign of love or hate?'). Then there was the sheer excitement of war itself ('We have been bombed three times in ten hours,' she told Jock Murray, 'and I'm afraid to say this is the only thing lately I've *really* enjoyed'). Above all, she felt wanted and useful. 'How lucky I am in this war,' she wrote to her mother, 'not a single week of tedium since it started ... I have been lucky enough to carry on what I have been aiming at for many years, and indeed find now the help and comradeship which I never had before. Personally it has been a great increase in happiness.'

With the invasion of Norway, Denmark and the Low Countries, the fall of France and the retreat of British forces from Dunkirk, Britain's position in the Middle East looked increasingly bleak. Arab nationalists, already restive under British tutelage in Egypt and Iraq, and inflamed by the British policy of settling Jews from Europe in Palestine, increasingly saw the Axis powers as liberators. The theatre of war had now shifted to the Western Desert, where General Wavell in command of some 64,000 men in Egypt and Palestine faced an army of 250,000 Italians under Graziani and another 300,000, including native levies, under the Duke of Aosta. Freya, with the consent of her masters in London, but to Stewart Perowne's annoyance, had herself transferred to Cairo, cosmo-politan capital of a formally neutral Egypt which also doubled as the General Headquarters (GHQ) of the only British army left in the field. There were about 80,000 Italians in Egypt ('all of them tied to Fascism by their purses, if not by their hearts,' wrote Freya); Italian influence was strong at the Palace, and even more so among the nationalist-minded youth of the Nasser–Sadat

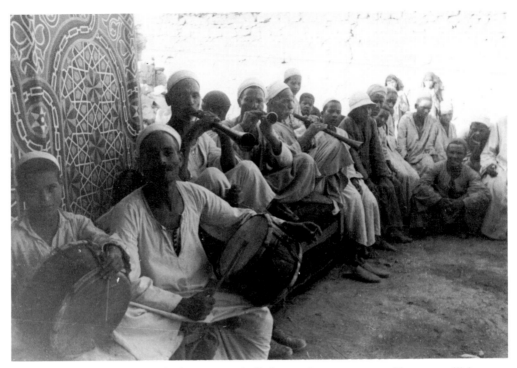

'If the news continues to be bad, we can rely little on pictures or pamphlets; we will have to call on a reserve which we have hitherto scarcely tapped – the desire of average people to *give* rather than to *receive*.' – Dervishes in Cairo, 1940.

generation, too ignorant of Europe and impatient for independence to see that an Axis victory would replace British paternalism with outright tyranny.

Freya's knowledge of the Arabs and her experiences in Aden and Yemen had equipped her well for the task of countering Axis propaganda in Egypt. She understood, and to some extent sympathized with, resentment against colonial exclusiveness, even though she remained an imperialist at heart. She understood, as few Europeans did, that eastern venality was skin-deep, that beneath a corrupt public morality which made it easy to 'buy' officials there were layers where the potential for disinterested action, rooted in Islamic values, lay dormant. Indeed, it was from just such layers that the volcanic fervours of nationalism or Islam periodically erupt. If it had been possible to bribe people into submission by material means, British administrators and Zionist colonizers would never have faced the problems they did in getting Egyptians, Palestinians and Iraqis to permanently acquiesce in their ambitions.

In Yemen and Aden Freya had developed the basic principles of what came to be her philosophy of propaganda. First, one must believe one's own message: if things were going badly, people must be told the truth. Second, the message

78

must be to the advantage of the audience as well as to one's own side: it was no good talking grandiloquently about 'freedom' and 'brotherhood' while denying them in practice with oppressive regulations or bureaucratic aloofness. Third, one should not spread the message directly, through press or radio, but disseminate it on an oral, personal, basis, among the people of the country. This last principle was particularly pertinent in the Middle East, where newspapers were usually under strict government control and tended to be looked on with suspicion, especially where, as in Egypt or Iraq, the governments were themselves under indirect British control. The message must be spread informally, not by paid agents who would lack credibility, but by disinterested people who were genuinely convinced by the justice of the cause. For this, essentially political reason, she had urged in Aden the establishment of a force of Arab volunteers to deal with fire-fighting and so forth. As she explained to Laurence Rushbrook Williams, her London chief, in the darkest period of the war before the Battle of Britain:

'... If the news continues to be bad, we can rely little on pictures or pamphlets; we will have to call on a reserve which we have hitherto scarcely tapped – the desire of average people to *give* rather than to *receive*. A show of power is an excellent way to appeal to the Arab; but there is also I think a natural and almost universal generosity that makes people glad to be asked for sacrifice and service; and we have rarely appealed for such things outside our own race. Now we have a rough time ahead, and it is not certain that the appeal of power will be at our command: we must rely on what we can do without the adjunct of success.

Does it not seem to you therefore that we must study deeply and swiftly all such methods as will rally to our side not the *interested* but the *disinterested* feelings of our districts? I have long wished to go more upon this principle ... It was for this reason that – when asked for a medicine against panic – we proposed the enlisting of the young Arab volunteers. It is probably quite true, as everyone tells me, that they will be no earthly good in a crisis; but I think the mere fact that they are giving something will inspire a loyalty which mere receiving will never do. Can you imagine anything more demoralizing than to sit in a bombed town *being looked after* – with nothing to do yourself!'

In Cairo Freya was given the opportunity to put her ideas into practice. With the help of an assistant, Pamela Hore-Ruthven, whose husband Pat was fighting in the Western Desert, she launched the Brotherhood of Freedom, a movement dedicated to the cause of anti-Fascism and democracy. It avoided being overtly pro-British. Instead it argued for democratic against totalitarian values, stressing the democratic elements in Arab and Muslim tradition. Members, recruited by word of mouth, met regularly for discussion and briefings, when 'whispering campaigns' were launched to counter Axis claims in the souq. The spirit of

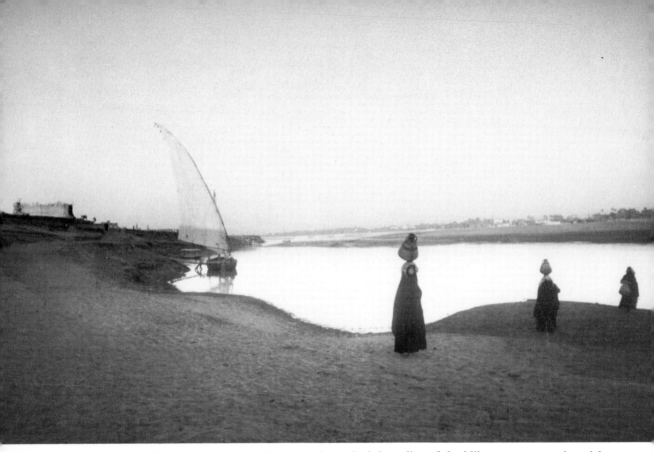

'For a whole week we forgot the war and watched the valley of the Nile, an easy span but rich under harvests, dense with villages, where mists lay low even when the outer stars were clear at night.' – Egypt, 1941.

truth was maintained as closely as possible. After Rommel's counter-offensive in 1942, when the loss of Tobruk was imminent, Freya insisted on forecasting its fall a week before it happened, against the advice of most of her committee members. Her candour was rewarded when news of the victories of Alamein and Stalingrad was perceived as truthful, bringing new members into the movement.

The membership built up gradually at first, but then grew exponentially. By December 1940 Freya had recruited 200 members; by June 1941 there were more than a thousand. By January 1942 there were 200 committees with over 3000 members; by April, with Rommel hammering at the gates of Alexandria, there were sixteen thousand. After the danger to Egypt had passed, membership steadied at around twenty thousand. It remained at about this level till after the war, when the Egyptian government, locked in conflict with Britain over Palestine and the Canal Zone, disbanded it.

'Cairo was the centre of our world during the first three years of war, the stage on which all glances south of the Alps were focused,' wrote Freya in her

final volume of autobiography dealing with this period. Its special glamour –
like the Duchess of Richmond's ball on the eve of Waterloo – lay in the
knowledge that a life-and-death struggle was imminent, on which the fate of
Britain and the whole Middle East depended. There was none of the austerity
– food shortages, black-outs, rationing and price-controls – that afflicted the
cities of the combatants in Europe. The Egyptian economy boomed, as con-
tractors made fortunes from supply, soldiers on leave blew their pay packets in
bars and brothels, and officers exchanged battle fatigues for the elegance of
mess-wear, in order to dine at Shepheards or the Continental, or dance with
the girls from GHQ in Cairo's numerous night-clubs. For under the peculiar-
ities of the 1936 Anglo-Egyptian treaty, the vast allied military juggernaut that
was swelling to combat Rommel's offensive was there as a 'guest' of the tech-
nically neutral Egyptian government. The young King Farouk, though he vir-
tually owed his throne to British support, tried to keep his options open by
flirting with the Axis, until the British ambassador, Sir Miles Lampson, a
formidable granite-hewn giant with a robust pro-consular way of doing things,
surrounded the king's palace with tanks and ordered the young monarch to
appoint a government of his own choosing. This was a national humiliation the
Egyptians never forgot.

In Cairo, Freya was in her element. Already a minor celebrity from her
travels, she became a person of consequence, respected by generals, courted by
socialites, admired by young officers. General Wavell – the epitome of a certain
kind of silent and modest, but cultivated Englishman she tended to idolize –

'General Wavell ... a great man with a
simplicity and gentleness about him that
makes one love him ... When one is lonely
there is something very *healing* in people who
are so genuine and whose affection you feel
is just for yourself alone ...' – Field-Marshal
Lord Wavell, Viceroy of India, 1945.

81

'The Fayyum ... is a large fertile oasis, with many villages that live this island life, among lush groves and vegetable plots, and fat poultry and many-windowed domes of clay that look like temples but are really dovecotes, at the entrance to every group of houses.' – Faiyum, Egypt, 1941.

became a friend. He brought his wife to dine in her flat overlooking the Nile (a tremendous compliment from the Commander-in-Chief of an army at war); and listened politely when she shyly penetrated his office to outline a scheme for a landing on the Ligurian coast, where she knew anti-Fascist sentiment to be strong ('I can't spare the men,' Wavell said, sadly shaking his head). Prince Aly Khan, son of the Aga Khan, who had been commissioned as a colonel in a British regiment, joined one of her committees, to hold court among some of his father's followers surrounded by playing fountains with goldfish. Freya met General de Gaulle, who impressed her ('... rather like a Rodin ... cut out roughly and unfinished, with beautiful and very carefully done bits here and there, such as his hands and his eyes and brow'), and Randolph Churchill, who didn't ('He is spoilt like a pretty woman, and for the same reason – they get without effort what others have to earn'). When the work got too big for herself and Pamela, she acquired a second assistant – a dark-eyed Syrian beauty named

Lulie, daughter of a former Prime Minister of Transjordan, possessed with an Oxford degree and a string of influential relatives throughout the Middle East. She dined regularly with the Lampsons at the British embassy, a fine Edwardian villa with lawns stretching down to the Nile, from which the great Lord Cromer had effectively ruled the country before the First World War; and she accompanied them on expeditions to El Faiyum and Luxor.

She even acquired a motor car (a Standard Eight) and took driving lessons which do not seem to have taught her much. The car, she wrote, is 'great fun and one of Cairo's standing jokes' – unless one happened to be standing anywhere near its path. ('Why are you savaging that innocent hotel,' asked Arthur Longmore when, mistaking her gears, she backed into Mena House.)

Freya's erratic driving remained notorious, as Asolo's citizens will testify, and she never acquired more than a superficial acquaintance with the workings of a car. This did not prevent her, however, from embarking on what even in wartime must have seemed a risky venture – a journey, solo, through Palestine and Syria, to Baghdad. She encountered her first hill (for Egypt is quite flat) near Beersheba, where the road ascends to a high plateau, negotiating the

'One has this feeling everywhere among the poorest of our groups: a feeling of old dignity which makes hut and palace essentially the same.' – Freya in Baghdad, c. 1942.

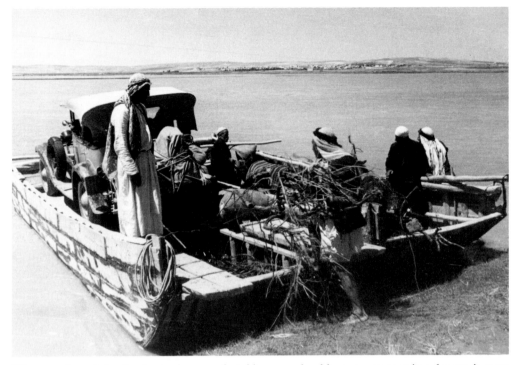

'The crossing of the Euphrates is an undertaking one should never attempt in a hurry: it may take six hours. The old ferry-punt is pushed into midstream with poles and then drifts to the other side miles down, and is towed up again with ropes. One would think that in 6000 years or so they might have invented oars!' – Euphrates ferry at Sirrin, Syria, 1939.

unfamiliar curves with 'the breathless, painful joy of the débutante when first she ventures onto a dancing floor'. Shortly after leaving Jerusalem, the starting-handle came away in her hand, but an Arab truck-driver fortunately stopped to show her how to manage without. She stalled in the Samarian hills, but managed to get a push-start from some friendly villagers. She took the road that follows the pipeline across the Syrian desert, only to stall again in the heat of the day. A passing taxi-driver explained that the extreme heat vaporized the petrol in the pump, a problem that could be remedied by frequent applications of a 'cold poultice' – a rag dipped in water. This time she made it – with halts – to the far side of the Euphrates, where the radiator hose came unstuck. Having managed to fix it herself, she arrived in Baghdad with a justifiable air of triumph.

The idea of spreading the brotherhood in Iraq had come up during Freya's previous visit to Baghdad in 1941, against the dramatic backdrop of Rashid Ali's pro-Axis *coup d'état*, when the British embassy lay under siege for nearly a month. German influence in nationalist circles, especially among the military,

had always been strong in Iraq. Encouraged by German advances in Greece, a group of four colonels, popularly known as the 'Golden Square', took control of the army and surrounded the regent's palace with troops. At the time the king, Feisal II, was a mere boy of seven, and his uncle, Abdul Ilah, was in charge of the monarchy. The regent escaped, hiding beneath the cushions of the American Minister's car. The colonels deposed him, appointing a regent of their own. Parliament was summoned and endorsed a new government, more sympathetic to the Axis than its predecessor, under the veteran politician, Rashid Ali al Gailani.

The British were in a delicate position. Under the terms of the 1930 Treaty of Alliance with Britain, Iraq was obliged to make its railways, rivers and ports available to the British, as well as the RAF base at Habbaniyah (used mainly as a training establishment). To avoid giving the British any excuse for moving against him, Rashid Ali made it clear that he intended to strictly observe the treaty. Churchill, however, decided that the situation was too dangerous to leave to diplomacy, and resolved to use force. A brigade, diverted from Burma, was landed at Basra, and the incoming British ambassador, Sir Kinahan Cornwallis, intimated that British recognition of the new government would only be granted if the troops were allowed to land. Rashid Ali agreed to this, but baulked at a second landing of troops until the first had been evacuated. The situation became increasingly tense. Mobs took to the streets of Baghdad, placing the British embassy under siege. The British reinforced the base at Habbaniyah, and evacuated the women and children by air to Basra. The Iraqis moved a brigade to the plateau overlooking the air base, and issued orders forbidding all flying. The commander of the base (Air Vice-Marshal Smart) with full backing from London, decided to attack the Iraqis from the air before they had time to shell the base. The British used everything they had – elderly Wellingtons, uncamouflaged Audaxes, ageing Oxfords and a motley collection of training aircraft manned, in the absence of qualified pilots, by uncertified pupils. After five days of intense bombing and Iraqi counter-shelling, the Iraqis were beaten, their brigade destroyed at Al Fallujah. The German Luftwaffe, arriving by courtesy of Vichy-controlled Syria, came too late to make any difference. There was an element of farce in their operation: the leader of the German squadron, Major Von Blomberg (a son of the Field Marshal), landed in rebel-controlled Baghdad, only to be hauled out dead from his Messerschmitt, having been shot through the head by an over-enthusiastic Iraqi soldier accustomed to blazing off wildly at everything airborne.

During the crisis leading up to the embassy siege, Freya had been on leave in Persia. Sensing that trouble was coming, she cut short her holiday, missing (happily from her point of view) a message from Cornwallis urging her to stay

in Tehran. The Iraqi police stopped her at the frontier, with orders that no one should be allowed to proceed to Baghdad.

'Did your telegram say that women as well as men were to be prevented from going to Baghdad?' asked Freya, fixing the young lieutenant with her gaze.

'No,' replied the lieutenant, 'it said travellers. It said nothing about women at all.'

'It would be a nuisance for you to keep a woman here,' Freya announced with finality. 'You would have to find a separate house, and of course you would have to find me a maid. I never stay anywhere without a maid.'

Freya was put on the next train to Baghdad. She reached the embassy on 3 May, just as they were finally closing the gates.

When Freya arrived, they were busy burning documents in the chancery. About 350 people had taken refuge in the embassy compound. Apart from the British staff there were Indians, some Iraqi Jews and about half the embassy's complement of Iraqi domestics or *cawases* who had chosen to remain at their jobs, rather than risk nationalist reprisals at home. Freya shared a dormitory with sixteen women in what had formerly been Lady Cornwallis's magnificent bedroom overlooking the Tigris. In the ballroom downstairs, the refugees huddled in groups, surrounded by their belongings. Freya noticed how much better adapted easterners were to this style of life than Europeans, despite the embassy's western trimmings. With carpets and samovars usually at hand, they would instinctively form a circle: 'while we, each defending his own privacy,

'The Chancery is a bonfire, mountains of archives being burnt in the court, prodded by staff with rakes; black cinders like crows winged with little flames fly into the sunlight. The state of siege has been going on for three days.' – British embassy, Baghdad, May 1941.

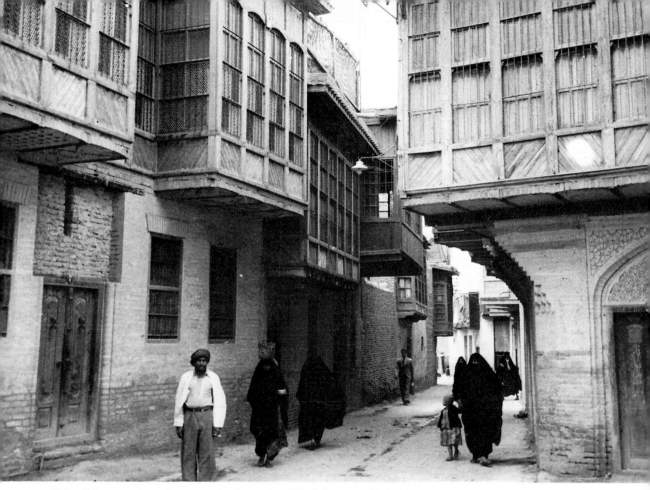

'Muadhham ... is a pleasant suburb north of Baghdad, an old-fashioned place with nice quiet streets and houses overhanging, with triangular dusty carved windows pushed out to get the maximum light and view for the harem.' – Baghdad, 1942.

vainly try to make small barricades of our boxes and belongings'. There were problems with the servants, which Freya set herself to iron out. Food was scarce, but available. After a week during which they consumed all their stores, Captain Holt, the oriental secretary, arranged with the Iraqi Foreign Ministry to buy some more supplies. Fortunately, there were certain people in the government who sympathized with the British, and wished to keep the lines of communication open.

By the end of May, the revolt had collapsed. The siege was lifted. After briefly returning to Cairo and Palestine, Freya came back to settle in Baghdad the following September. Pamela arrived, to help her furnish a house she had rented in the suburb of Alwiyah, but was soon forced to leave by the impending birth of a child. (She returned to her parents in Ireland by sea, chased by U-boats around the Cape, to deliver him, the present author, safely in Dublin.) Freya learned that her mother, who had briefly been interned in Treviso after

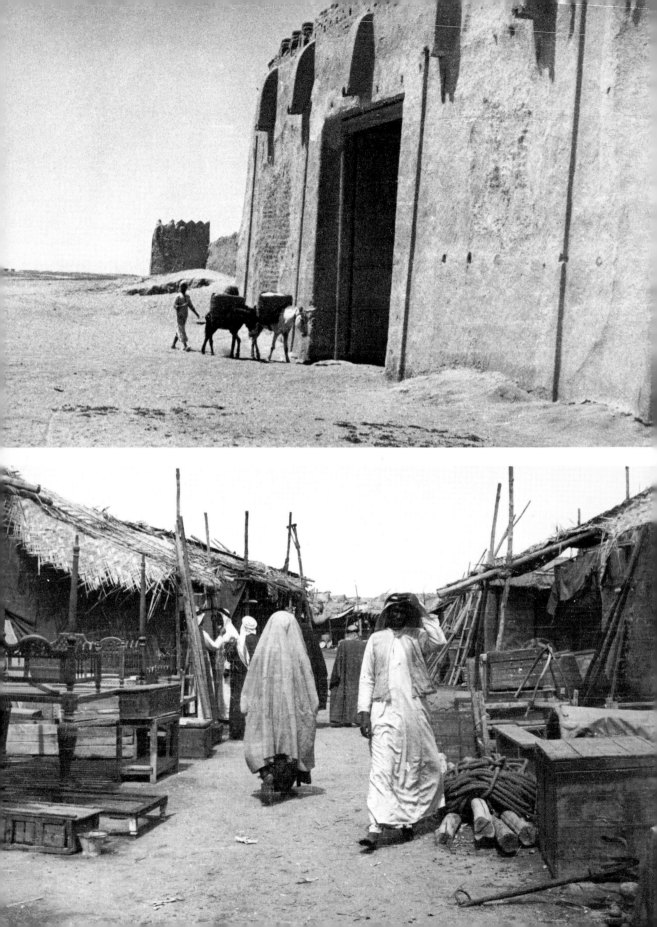

reports from the Italian consul in Aden about Freya's activities, had, through the help of influential friends, been allowed to travel to the United States. The ordeal had been too much for the ageing Herbert Young, who fell ill and died, aged 86, before they could set sail together. Freya's happiness to know that her mother was safe, however, was not to last. She died the following year, 'a vivid, entrancing presence' remaining in Freya's memory.

In Iraq the brotherhood flourished, helped by the defeat of Rashid Ali and the turning of the tide at Alamein and Stalingrad. By December 1942 there were more than 1000 members, with new recruits coming in at the rate of 500 a month.

Freya acquired two new assistants, Peggy Drower, 'pleasant, tactful and with good Arabic', who had been brought up in Iraq, and Barbara Graham, 'rather attractive, with a very pretty mouth and smile', who 'would be a pleasant companion if one didn't have to expect her to work'. They made a ten-day tour of Kurdistan, where they were gratified to find that the tribesmen were staunchly pro-British. 'They all come up in their turbans and big woollen suits slung about with guns and cartridges and say, "We are ready to fight for you whenever you want us",' wrote Freya.

By the summer of 1943 the brotherhood was well enough established in Iraq for someone else to take over. There were now some 6500 members, and well over twice that number in Egypt, where the movement had already been en-trusted to the capable hands of Christopher Scaife. As an exercise in goodwill and the art of persuasion, it had been a success. Whether or not the brotherhood would have stood the test of enemy occupation, however, is another question. The idea was to use it as a kind of 'fifth column' behind the Axis lines. The victory of Alamein ensured that it was never put to the test.

Despite the goodwill towards Britain that still remained among the more moderate nationalists like the Iraqi statesman, Nuri el Said, who never wavered in his support, there remained one obstacle faced by all who sought to win friends or influence among the Arabs, and that was the rock of Palestine. Under the Balfour Declaration – an ill-thought-out document designed to elicit the support of the Jews of Germany and Russia in the emergency of 1917 – Britain

Opposite above: 'This is a lovely place to be in: the weather delicious, hot at midday, but too cold to sit in the shade without a *very* warm coat ... Yesterday afternoon we drove out of the Southern Gate across the desert, now pleasantly green over its yellow earth ... I don't know what I shall have to pay to ransom fate for one month's perfect happiness.' – Kuwait, March 1937.

Opposite below: 'The sea is shining and the old boats are all drawn up ... a little shabbier than they were five years ago since Kuwait is suffering from the slump in pearls. They are going to find oil instead. In the morning I spent all the money I have, and lots more ...' – Kuwait, 1937.

had promised a 'National Home' for the Jews in Palestine, 'it being clearly understood that nothing shall be done that may prejudice the civil and religious rights of existing non-Jewish communities in Palestine'. The two halves of the Declaration were, it is now obvious, mutually incompatible. The Zionists and their supporters, who grew more radical in their demands as the Nazi persecutions gained momentum, focused on the first part of Britain's obligation; the Arabs and their supporters on the second. The British, as the Mandatory Power in Palestine tried, with decreasing success, to hold the balance. The scale of immigration, following the Nazi rise to power, saw the Jewish population increase from some 50,000 people at the end of the First World War to around half a million at the beginning of the Second. This dramatic shift in the demographic balance provoked a full-scale Arab revolt in 1936 which the British put down with considerable severity. A Royal Commission in 1937 recommended partition of the territory into Arab and Jewish states. But this met with such overwhelming objections from the Arabs at a time when their support was seen as crucial, that it was overruled. In 1939 the Colonial Secretary, Malcolm MacDonald, produced a White Paper limiting Jewish immigration according to the 'economic absorptive capacity' of the country, with a ceiling of a third of the total population. At the outbreak of war, this meant that the authorities would only allow a further 29,000 Jews into Palestine. The policy was overwhelmingly rejected by the Zionists. At a special meeting at the Biltmore Hotel in New York in May 1942, the all-important American branch of the movement affirmed its 'unalterable rejection' of the White Paper which it denounced as 'cruel and indefensible in its denial of sanctuary to Jews fleeing from Nazi persecution' and demanded that 'the gates of Palestine be opened' for unrestricted immigration. The Zionist movement and British policy in Palestine were set on a collision course.

As early as August 1942 Freya's bosses at the Ministry of Information mooted the idea that she should go to the United States to explain British policy to the Americans, pointing out its eminent reasonableness. At first she was reluctant to go. She felt that someone younger and more glamorous like Pamela, 'who seizes everyone's heart', would create a bigger impression. But duty eventually persuaded her and in November 1943 she boarded the *Aquitania*, along with 5000 troops and a handful of mothers and babies bound for Halifax in Nova Scotia. Four days out from England she developed acute appendicitis and spent the rest of the voyage in her bunk, the ship's hospital being already full. By the time she was taken off the ship, the appendix had burst. But she survived, thanks to skilled surgery and devoted nursing. Within a month she was in New York, dazzled by the 'Babylonian' beauty of its tall pencil buildings, each with its own individuality 'like the towers of San Gimignano or Bologna'.

She soon found herself subjected to a punishing schedule of lunches, dinners, ladies' club gatherings and lectures, from New York to Chicago and California. She tried to win the support of 'moderate' Jews, like Mrs Guy de Rothschild who, Freya felt, 'would yield to a firm attitude, if only HMG would decide to take it'. At one gathering Mrs Rothschild went so far as to tell Freya that what she disliked about the Zionists was 'their Nazi principles'. 'I think it is one of the propagandist's purest pleasures', Freya commented, 'to see his own words coming back dressed up as Other People's Ideas.'

Like other Arab sympathizers who had seen the Palestine situation at first hand, Freya was generally hostile to the Zionist settlers. She found their obstinacy and exclusiveness as objectionable as an earlier generation of imperialists had found the very similar characteristics of the Boers of South Africa. She strongly defended herself against the charge of anti-semitism. Despite occasional lapses caused by exasperation ('The only way to deal with these people', she had written to her mother in 1941, 'is by the occasional massacre'), her position was generally consistent. She set it out most clearly in a letter to the *New York Times* in April 1944:

'Sir,

I am asking for the hospitality of your columns to speak on behalf of people who, like myself, are admirers and friends of the Jews and yet are strongly opposed to the policy of some among them in Palestine.

The Jewish race has behind it a long tradition of international liberality and civilization: it has for centuries been in the vanguard of those who are leading away from the narrow bounds of Fascist nationalism towards a more cooperative world, and many of its number, among whom I count some of my best friends, feel as strongly as I do that it would be a pity to exchange this honourable place in the van of progress for a reactionary policy. To try to impose themselves *by force* on a people such as the Palestinians who have been in the country 2000 years and more and who have already accepted a total Jewish population equal to one half of their own, to increase this total *by force*, would I think, be not only against all principles of liberality and justice, it would eventually be against the interest of the Zionist community already established there.

I have been accused of anti-Semitism because, in lecturing on the Arab world, I have (when questioned) expressed these views. I wish to put it on record that I am in no sense anti-Semitic, and indeed I am not anti-Zionist except insofar as I feel that their establishment in Palestine can only rightly be made *by agreement with the inhabitants of the country and not by force.*

It seems to me moreover that many Zionists are sacrificing the cause of the Jews in Europe to the cause of Palestine, and that, if they concentrated on other ports of refuge, we could all support them without the feeling that we are relieving one oppression by imposing another one.'

91

The last point, perhaps, was the most telling one: the Zionists had persistently opposed plans to ship Jews to places other than Palestine, including the United States.

In America Freya soon realized that such reasonableness and moderation would be difficult to sustain. Before the swelling tide of Zionist feeling, non-Zionist Jews were afraid to speak out for fear of being welcomed by the real anti-semites. American liberals, whose views she otherwise shared, were uniformly pro-Zionist and anti-British, their humanitarian feelings towards the Jews merging with the traditional American hostility to colonial governments. Freya was intrigued by the 'frankly barbarian' character of many of the Americans she met, people whom she likened to 'Goths revelling in the un-understood magnificence of a conquered world'. But she also found an 'awful blankness' about the country, a feature she traced, singularly, to the fact that the women were 'organized'. Like other cultivated Europeans, the people to whom she related most easily on a personal level were, in fact, the Jews, who alone among the peoples settled in North America seemed to share her outlook and general values. 'The distressing thing', she told Elizabeth Monroe, now her chief at the Ministry, 'is that I like the Jews I meet here and have to argue with, almost better than anyone else I see ...' When questioned, as she invariably was after lecturing on the Arabs (she never raised the issue of Palestine herself, if she could help it), she staunchly supported the White Paper, arguing that it came as near as was possible to fulfilling *both* parts of the Balfour Declaration, providing for the Jewish National Home while safeguarding the rights of the 'non-Jewish communities'. Generally, she was heard out politely, despite occasional heckling. 'I think there is much more noise than substance in the Zionist voice out here', she wrote to Pamela. 'I found most of the journalists, for instance, very fair and anxious to hear the other side.' She was to be proved wrong in this, as were all others who believed that the natural justice of the Arab case would triumph over Zionist 'noise'. But that was before the true magnitude of the disaster that had befallen European Jewry had been revealed, swelling the Zionist tide into a flood in which all considerations of natural justice, and Britain's obligations to the Arabs, were swept away.

Freya's final journey in the campaign of propaganda she waged on behalf of Britain during the war was to India, where Lady Wavell, now the Vicereine, invited her to set up an Indian branch of the Women's Volunteer Service. 'The English pattern of WVS', both Freya and Lady Wavell had decided, 'was

Opposite: 'The town is really one long street in the cleft of the valley, with the stream and the amphitheatre and various shreds of the old Greek masonry on one side out of sight.' – Amman, Jordan, 1933.

Above: 'I have had a romantic morning, climbing up about three hundred rough steps to the citadel of Golconda – it is just as enchanted as its name . . . You can't think what a beautiful landscape it was: the sun rising crimson and all the ridges that lie like scaly crocodiles across the Deccan outlined with swathes of creeping mists.' – Hyderabad, India, 1945.

Left: 'The Viceregal rickshaws have been sent in full rig, blue and red . . . in their crowd the old Mahatma sat very small, benign, cheerful and, as it seemed to me, *tough* – obviously cordial and pleased to meet all the good-looking young Englishmen in uniform gathered on the red-carpeted steps of the porch. I haven't spoken to him, but he had an atmosphere of great charm which one felt at once.' – Simla, India, 1945.

unlikely to appeal to a foreign intelligentsia panting for independence.' The plan for a kind of Indian Sisterhood, however, was overtaken by more momentous events – the end of the war, Wavell's departure and the appointment of Mountbatten with the specific brief of negotiating Indian independence. All that remained of her stay in India, Freya would write in her autobiography, 'is a happy, unproductive half-year in my memory'. She was privileged, however, to attend the Simla conference which set the stage for the bloody struggle that accompanied partition. She met most of the leading actors. At first she shared the viceregal view of Gandhi, whose saintliness seemed to her 'more bogus every word he utters', but she warmed to him after watching him smash a European press-man's camera. ('He has great charm and a most refreshing absence of the Indian inferiority complex ... Mr Gandhi gives out an aura of immense gentleness from some way off, but there is a harder and less innocent glint when you see him close up.') She met Jinnah, whose face she found 'just sparkling with intelligence, small features, eyes rather near, but strung to a tension like a bowstring about to shoot'. She sat next to Mountbatten at dinner, whom she found lively and handsome with an 'eighteenth-century nonchalance' she found attractive: and she met Nehru who seemed to her 'a gentle man who would have been happy if he could have worshipped and obeyed' but was unsuited, by temperament, to lead.

Freya left India at the point where the Simla conference had become deadlocked over Jinnah's demand for a separate Muslim state. A plane had been found which could fly her to Rome. From there, after several frustrated attempts, she finally reached Asolo, arriving one day in a military truck to find her house intact, with Emma, her mother's cook, and Caroly, her mother's secretary, on the doorstep to welcome her. Here she began reassembling the shattered pieces of domestic life, before setting out for further, less arduous, adventures.

PATHS OF EMPIRE

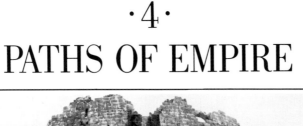

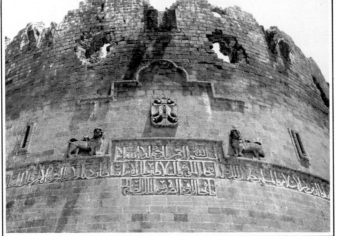

ITALY after the war had relapsed into a state of near anarchy. From its bases in the cities the Allied Military Government imposed severe rationing, which everyone who could afford it evaded by resorting to the black market. 'We have gone back to being a small hill-town with its gossip, trying (successfully) to thwart all the regulations of the central government which happens to be the AMG but might just as well be the Holy Roman Empire as the mutual feelings must be very much the same', she wrote to General Wavell from Asolo. With her connections with the British part of the AMG, Freya was well placed to help out her Italian friends. 'I seem to spend my days doing things of every variety for people,' she told Jock Murray, 'getting news of relations, arranging transport, freeing cars and houses; it's a pleasant change to see the few people who come in *without* wanting anything.' Freya now found herself in overall charge of her mother's silk factory, with ten mouths to feed, in addition to her two domestics, Emma the cook and Cecchi the gardener. Fortunately, the AMG

Opposite: '. . . women who, even in a world at peace, are busy with the fundamentals of life and death, who look Eternity in the face with the birth of their children, and Time with the passing of their youth.' - Dar Qita, Syria, 1956.

Above: 'Diyarbakir itself - have you seen it? Its black walls in the sunset with the Tigris lying round it like pale molten gold? The great bands of Kufic script in stone?' - Diyarbakir, Turkish Kurdistan, 1958.

turned a blind eye to her smuggling activities. 'Don't buy more food than you need,' they said, 'and don't get caught.' Freya was better off than most of her Italian neighbours in other respects as well. Where Fascist sympathizers were now ostracized, or worse, having already been prevailed upon to sacrifice their valuables voluntarily during the last critical days of the regime, known anti-Fascists had had their properties confiscated and homes ransacked. Freya's prudence in entrusting most of her valuables to be hidden by friends before the war broke out had paid off. The Fascists, who had made it their headquarters, had protected her house. 'For the last fortnight', she wrote in August 1945, 'things in boxes have been coming from all their hiding places.'

There were mixed feelings as she was reunited with her family, now all Italians. Both her nephews were lost, having fought on different sides. One had gone missing on the Russian front, after the terrible retreat from the Don: the other had died 'young and brave' with the partisans in the valleys of Piedmont. But her niece Cici, now 24 and uncannily like Vera 'with lovely eyes and a laugh like springtime' brought unexpected joy. In 1943 she had married Franco Boido, who was with the partisans, the day before he went into hiding. Three times he was captured by the Fascists or the German SS: twice he managed to escape. The third time, knowing that he faced certain death, his comrades took two Germans hostage. Cici managed to negotiate his release for two million lire and a bracelet. Cici spent three weeks in Asolo, to Freya's delight. She was fetched by her husband, 'a gentle, rather negative, nice and devoted young man' as well as Mario, now looking 'too frightful, like a fraudulent character in a play'. Freya's hatred of Mario had, if anything, increased. Despite his Fascist connections, he had done nothing to help her mother and Herbert in prison, although the only money she had was what he owed her. The experience of meeting him was painful, and Freya hoped she would not have to go through it again. She never did as Mario died a few months later, in 1947.

Freya's work for the Ministry of Information was not yet finished. She was taken on by the British embassy as a press attaché, with a roving brief to inspect reading centres for English books and newspapers in fifty north Italian towns. Her chief at the embassy, Michael Stewart, became one of her closest friends, remaining with Jock Murray and Caroly, her mother's former secretary, a pillar of support when she became old and fragile. Characteristically Freya's travels through a country demolished by war reinforced her faith in the human spirit. 'Each small metropolis', she would write, years afterwards, 'now calls up in my mind some picture, past or present, of its life. Sometimes it was the beauty of painting or stone, more often at that time some human piety, the disinterested, almost unquenchable, ant-like optimism that builds in the ruined world.' In the spring of 1946 her efforts in the cause of anti-Fascism were recognized by her

home town. In a gesture which also paid tribute to her mother's courage, she was presented with the freedom of the city. The ceremony took place (like a similar one, nearly forty years later, when she was given the key of the city) amid one of Asolo's torrential downpours, resplendent with tears and smiles. It was a sort of return, an act of reconciliation after the traumas of Fascism and war, 'a symbol of peace and the old friendships restored.' Though Freya often exhibited the northerner's impatience with the Italian way of doing things, her love of Italy remained undimmed. 'The real attraction here', she told an old English friend, 'is that with black markets, bandits, a useless government, and a long tradition of everyone for himself, life here is full of the Unexpected, and one day the world will discover that the Unexpected is even more essential than progress.'

The house in Asolo was now becoming comfortable again. Unexploded shells had been removed from the rose beds; new bathrooms, with special glass and marble fittings designed by Freya and her friend Osbert Lancaster, had been installed. One of them, Freya's own, was inspired by Botticelli's Venus. The bath was in the shape of a shell, with draperies in marble stucco concealing the shower. Her famous circular writing desk, with runners allowing it to be turned for easy access to different drawers and cupboards, was also built about this time, by local craftsmen whose workmanship was as fine as anything done in the eighteenth century. Italian skills at that time could be purchased cheap. Freya had a set of glass goblets made, copied from a Caravaggio, by Veninis of Murano, the famous Venetian glassmakers. Emma the cook had married Cecchi the gardener. Caroly, also newly married (to a banker), had taken charge of the silk factory. Gradually, as travel restrictions eased, English visitors began to arrive. Casa Freia became a successor of what Freya's German grandmother's house in Florence must once have been in Victorian days – an essential stopover on the Grand Tour for anyone lucky enough to be invited. Over the next decade or more (she sold the house in 1962) a procession of the great, the famous and a few of the obscure made the pilgrimage to Asolo. Laurence Olivier and Vivien Leigh, Bernard Berenson, Steven Runciman, David Cecil, Pamela Hore-Ruthven, Alan Lennox-Boyd, Alan Moorehead, Graham Sutherland, Michael Stewart, John Sparrow, Derek Hill, Charles Harding and, of course, Jock Murray, their spouses, appendages or children, became occasional or regular visitors, enjoying languid lunches under the vines, civilized English teas on the lawn beneath the ilex tree (the relic of what had once been a tiny Roman amphitheatre with a breathtaking view of the plain of Padua and Shelley's Euganean Hills), picnics in the nearby Monte Grappa, expeditions to Venice or the Dolomites, evenings spent playing Scrabble in the library or in animated conversations about Literature, Art, Love or Life.

'Old rows of houses of rubble piled to three storeys with no level spaces, like children's mud with crazy steps and no windows.' – Tunisia, 1961.

Freya, with her high Victorian upbringing, her youth spent partly in European exile, her experience of travel where only personality, not position mattered, her firmly established niche in the cathedral of letters, could afford to address people and issues with a directness that the sophisticated usually shun. It was a quality that endeared her to young people, notably her numerous godchildren, their siblings and friends, who were invited to stay in Asolo, with or without the encumbrance of parents, to mix freely and democratically with their eminent seniors, who might be ambassadors or masters of colleges. She would take her young friends on expeditions – to the mountains, to the Greek islands, or even further afield, to the Middle East or Himalayas. In some ways, no doubt, she sought to replicate the special relationship she had enjoyed with W. P. Ker; but perhaps she also found the worldliness of her more eminent contemporaries arid or slightly daunting, and sought refuge in the fresher foliage of youth, more sure that her role as a dispenser of wisdom would be appreciated.

Opposite: 'On and on and no other traveller on the path, to the highest mountain which has St Elias (from Helios the sun-god) in its chapel; under its shoulder half-way up the sheer face a monastery is dedicated to the Virgin. Two monks only are left and it was only trickling from its great days when it was the jewel of the island.' – Monastery, Amorgos, Greek Cyclades, 1966.

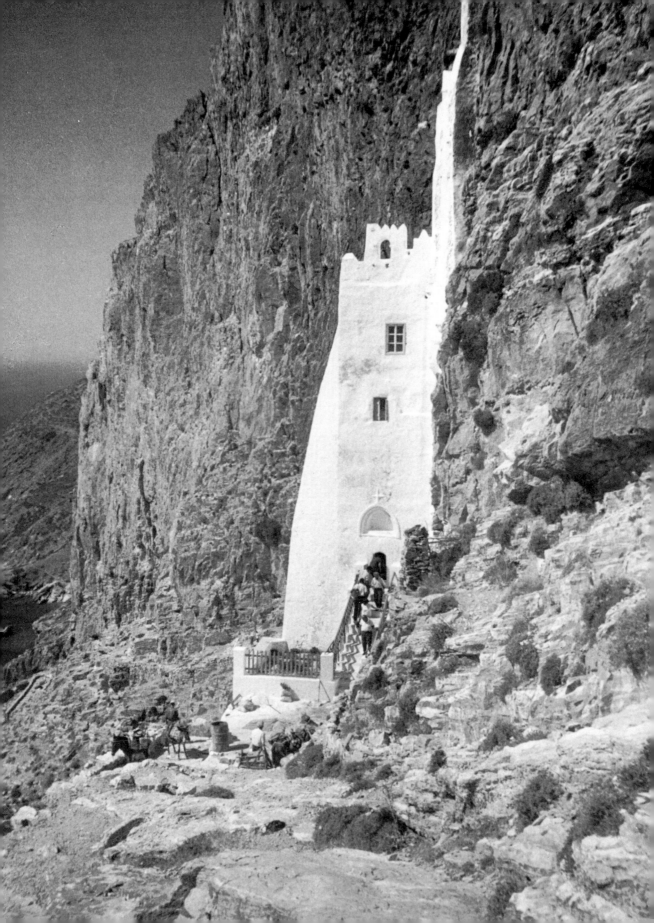

A streak of naïveté, combined with fearlessness, had been part of Freya's secret as a traveller: like a child, she had been prepared to venture into unknown territories regardless of danger or of the complications her actions might have had for other people (for example, when the RAF had to rescue her from almost certain death in the Wadi Hadhramaut). It was these same qualities, the product of a nature at once curious and insecure, that seem to have led her into the costly mistake of marriage to Stewart Perowne. Most marriages between people of middle age succeed, because both partners are likely to know what they want from a relationship and experienced enough to be able to negotiate it. It is not clear from the letters to her husband that Freya allowed to be published, whether she foresaw any of the implications that marriage must have.

Perowne had been oriental counsellor at the British embassy in Baghdad where his penchant for sending elegant and fastidious memorandums, written in a somewhat self-conscious literary style, made him famous inside the Foreign Office (and the object of amused comment by at least one historian of the period). He had stayed at Asolo in the summer of 1947 and, as ever, Freya and he found they shared a good deal of common ground in books, friends and even music. On returning to London Stewart found he had been posted to the West Indies. He proposed by telegram, and Freya accepted. 'I believe he just couldn't bear to go alone and had to have a wife among his tropical kit,' Freya told Nigel Clive. But if Stewart (as seems probable) saw it as a marriage of convenience between two old friends, Freya had other notions. Having previously been cheated of marriage, by desertion, she wanted matrimony in the fullest sense. This was hardly fair on Stewart who, more worldlywise, assumed she understood the kind of marriage he had in mind. The wedding took place in London where Freya had acquired a voluminous trousseau of frilly bed linen and negligées which caused considerable apprehension to some of her friends, who knew of Stewart's bachelor habits. They had a short honeymoon in Asolo before Stewart set off for Barbados, where Freya joined him the following February.

From the start it became clear that Freya would not do as an ordinary colonial official's wife. In Barbados she found that Stewart had 'turned into a perfect Civil Servant, completely occupied by files and minutes and *things that are done*', she told Jock. 'I do think there's an element of *darkness* in the government service; it makes people think themselves important, a *frightful* thing to do. I would rather sit among the Negroes in their touching little Methodist wooden chapels than take an official view of my only life in this earth.' But it seems there were more private disappointments as well. 'I did look down into an abyss', she told Jock Murray later, 'and am still very wobbly.' Instead of spending the whole summer with Stewart, she returned to Asolo

after only two months. On the first anniversary of their marriage, she wrote tenderly: 'I have been thinking over all this year, full of strangeness and find rather to my surprise that I do not really love you less! How astonishing! I think you have left something lying between us, untold. Whatever it was, it will not make me think less of you or care less for you . . .'

'It is one of the happy things that Stewart likes the people I like. We have a common world to set out in.' – Freya and Stewart Perowne after their wedding, September 1947.

Towards the end of the following year, 1949, Freya and Stewart tried to patch up their marriage. She acquired a motor-scooter on which they rode perilously around Padua, Perugia, Florence and Rome. 'The Vespa is quite a good substitute for a horse and does the same sort of country,' she told Jock. Despite a tumble from the scooter, they got on well together. The chances of mending the marriage seemed to improve when Stewart was posted to Benghazi in the newly independent Kingdom of Libya, where Freya joined him in the spring of 1950. 'It is very pleasant and feels like a return to one's own world to be again on this side of the Mediterranean', she wrote to Jock, 'with its cheerful squalor, gay dishevelled dirt and beauty.' But once again, she was

'Perhaps it is ease that we must *never* have, always we have to be on tiptoe, to grow a little towards what we may be; and as soon as we stand comfortably on what feels safe ground, the very ground opens and swallows us . . .' – Afghanistan, 1968.

defeated by officialdom and the 'memsahib atmosphere of the officers' club' which, she said, made it impossible for her to write. She stuck it out for four months, and went back again for Christmas and the New Year of 1951. Tormented by headaches, she returned to Asolo in March. In the summer she made a grand tour of England and Scotland, where she could now count on staying at the best addresses: Sissinghurst with the Nicolsons, Hatfield with the Salisburys, Cliveden with the Astors, Houghton with the Cholmondelys, where she met and photographed Queen Mary, and Windsor Castle where Lord Gowrie, Pamela Hore-Ruthven's father-in-law, was Lieutenant Governor and Deputy Constable. In September 1951 Stewart's job as adviser in Benghazi was abolished, and she spent three months with him in Paris, where he was now attached to the United Nations. But by the following March the decision to separate finally had been taken. 'Let us, for goodness sake, stop thinking of each others' faults and be good friends instead of bad spouses,' she wrote from

'I think one learns slowly how little of a separation death is: it is *life* that separates, and all the divisions that it makes vanish away and only the good remains.' – Muslim cemetery, Istanbul, Turkey, 1962.

Asolo. They continued to correspond, but ever more sporadically. In 1959 Freya re-read Stewart's letters, and decided it had all been a mistake. 'I am sure I was not the woman for you, dearest Stewart, because I am not *maternal*. A good comrade, lover or friend, I think, but very reluctant really to be looking after other people's lives.' This letter was published, but never sent.

It was at the time of the break-up of her marriage to Stewart that Freya became seriously interested in classical history. Stewart himself had an abiding interest in the period, which would later be demonstrated in several fine books about Roman Palestine. Freya never greatly fancied the Romans, whom she regarded as brutal proto-fascists. But she greatly admired the Greeks, especially in Asia, where they introduced the first sparks of western civilization. She began her investigations in 1952, with a visit to the ancient cities of Ionia.

As yet undiscovered by tourists, the coast of Western Turkey was littered with the neglected relics of Greek civilization. In the course of three months

'The hillside was scattered sparsely with tombs, whose doors and windows and rafters were chipped to look like houses, among the giant yellow sage and bright arbutus, and the honeysuckle scent and broom.' – Lycian tomb near Myra (Demre), Turkey, 1956.

Freya visited some fifty-five sites and only met another sightseer in one of them. 'I can't give you anything but a mass of details as it is *too much* to take in all at once,' she told Jock Murray. 'It is just like the first winter in the East, a whole new world pouring in; but here, it is the Greek world, our own origins, and therefore so deeply stirring.'

Freya immersed herself in Herodotus, the 'perfect travelling companion', with a view to exploring all the cities mentioned in his history. Her purpose was to deepen her understanding of the human and natural landscape, to 'fill out the meaning of space with something of its substance in Time'. Part of her exploration was conducted with David Balfour, from aboard his yacht *Elfin*.

Opposite: 'Columns were everywhere, of red onyx and green cipollino . . . It almost makes one regret the Italian loss of Tripoli, as this glorious excavation is now trickling along very slowly. It gives one more the feeling of Rome and what she meant than anything I have seen, certainly more so than Rome itself.' – Leptis Magna (Libya), 1960.

'A day in a coasting steamer through the Sea of Marmara takes one to Byzantium from Canakkale. The snout of Gallipoli is opposite, and Troy is on one side and the Australian columns of Cape Hellas on the other. The liners go by as if the passage were a polished floor and the events of history crowded on either side to watch the dancers.' – Sea of Marmara, Turkey, 1960.

For weeks they visited islands and remote promontories that would otherwise have been inaccessible. Balfour she described as a 'northern buccaneer' like herself. Having run through several religions, including a spell as an Orthodox priest, he had abandoned religion altogether, concluding that 'Man was one of God's mistakes'. He never allowed his official duties as British consul in Smyrna (Izmir) to interfere with the pleasures of yachting and fishing.

The books that resulted from this sojourn, *Ionia: A Quest* and *The Lycian Shore* are pleasing journeys into the past where the landscape combines with history to create a lasting impression of a long-vanished world. 'In these places,'

Opposite: '... as the darkness crept towards the water, a caique dropped downstream bringing the women home. They filled the benches and sat on the gunwale, their heads wrapped in white ... but with a country solidity about them. The evening closed round them, trailing amethyst mists.' – Cotton gatherers, Caunus, Turkey, 1952.

wrote Freya, 'the natural features have remained unaltered; the moments that visited them, fashioned to one pattern by nature itself, drop like beads on a string, through long pauses, one after the other, into the same silence.' The vigour of those ancient cities, with their triumphs and quarrels, and their eventual defeat at the hand of Persia, contrasts with their current neglected state where the only attention they receive is to provide building materials for Turkish villagers. 'What is so fascinating', Freya wrote to Jock Murray after

'They were rough folk and mostly plain to look at, with the excellent manners of the Turkish village, the result of a sure and sound tradition handed from generation to generation, which breaks into gaiety when ceremony demands it, as an earth-feeding stream breaks into the sun.' – Women at a circumcision, Cnidus, Turkey, 1952.

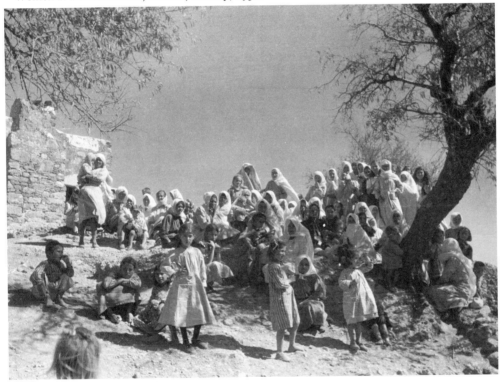

Opposite above: 'We rested, and then continued till the easy valley ended in a bowl of rocks and grass beneath a Dolomite crest called Deri Dagh. Pleated stiff like starched lace or the plumes of an Indian chieftain, it shone as we climbed beneath it ... It looked like a Persian landscape of sand-coloured slopes that held the brilliant trees and small mud houses, with patches of orange or green peppers drying on the roofs.' – Deri Dagh, Hakkiari, Turkey, 1958.

Opposite below: 'It was like some Arabian tale, where everything is granted but escape; for the imprisoned valley grew richer as we advanced, with clusters of vines hanging over the pathway and fig trees with purple fruit in pools of shade.' – Near Gunus Han, Turkey, 1958.

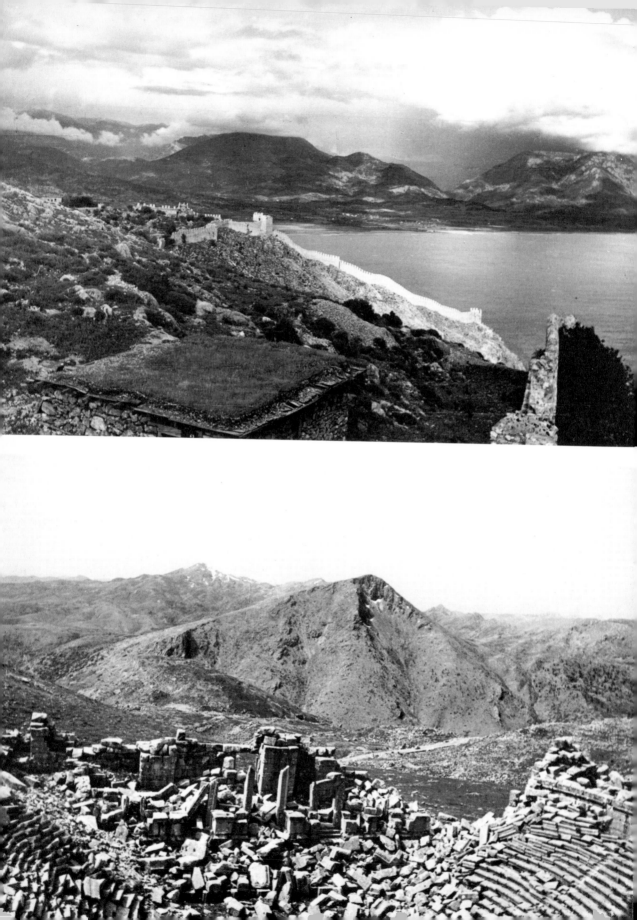

visiting Caunus, 'is the feeling of layer upon layer of Time, the Cyclopean stones old already when the later elegant Greek blocks were building, the vulgar *modernity* of the Roman baths, a beautiful grey *cella* of a temple with four fluted engaged columns on either side of a door still standing and a chaos of fluted drums, black stone bases, pieces of wall/column lying around. If I were a millionaire I shouldn't pay for excavations, but I should get an archaeologist to tidy up a site like this, collecting and reestablishing the fallen columns and

'Chaotic stone, cornices and capitals in pieces, lie heaped under brambles and grass. And the easy atmosphere remains. I believe it to be due to something proper to the precincts of Aphrodite – that absence of a feeling of inferiority which ... gives its lightness to the remnants of the Greek character tossed about in stone.' – Aphrodisias (Geyre), Turkey, 1956.

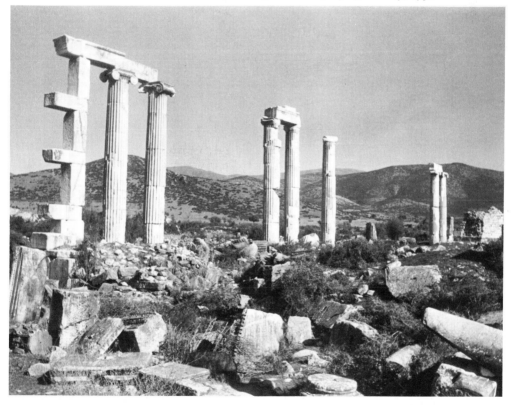

Opposite above: 'Beyond all military architectures, the early Greek and the Seljuk seem to me to express the delight of their building. Functional as they are they reach their perfection regardless of expense or effort, and a sort of radiance inevitably follows, as if the axle of immortality ran through them.' – Alanya, Turkey, 1954.

Opposite below: 'We went on and up, zig-zagging over bad roads where Alexander attacked straight, and found the city on a long spur with its tombs cut in the cliff of the mountain behind and its theatre tucked into the hill.' – Sagalassos (Aglason), Turkey, 1954.

making a beautiful thing, a standing temple in the landscape as it was first designed.'

Alexander's Path is the natural sequel to *Ionia* and *The Lycian Shore*. After the Greek cities had fallen under the Persian yoke, the Macedonians arrived as liberators. Freya chose to follow the path through Lycia (Southern Turkey) which Alexander took after the victory of Granicus in 332 BC in order to close the Greek ports against Darius's Persian fleet. The country is wild and rugged, the mule tracks numerous and confusing. In Alexander's day they could only be identified with the help of local guides. Without a supply train or fleet, the conqueror had to rely on whatever he could extract from the cities to pay his men. Yet generally this help was freely given, because Alexander promised the cities their freedoms, backing the local democrats against the ruling oligarchies favoured by the Persians.

But Alexander did much more than bring freedom to the Greek cities. He Hellenized the whole culture of Asia Minor, so that Homer, Sophocles and Euripides came to be read by Greeks and non-Greeks alike. 'No Empire, before or since,' wrote Freya, 'has been so persuasive, nor has any conversion except a religious one been so complete and widespread.' If she hero-worshipped Alexander, it was because he represented the qualities and ideals she most admired – phenomenal physical courage, a quick-thinking decisiveness in battle

'One could *see* the battle: the foothills where the Persian left tried to get round and was driven up by a preliminary action into the heights; the cavalry fight towards the sea where now, among the flats, a low green mound goes by the name of Issus; and the wide grey bed where Alexander and his white-plumed helmet pushed in with his guard about him ... What a fine way to learn history!' – Issus, Turkey, 1954.

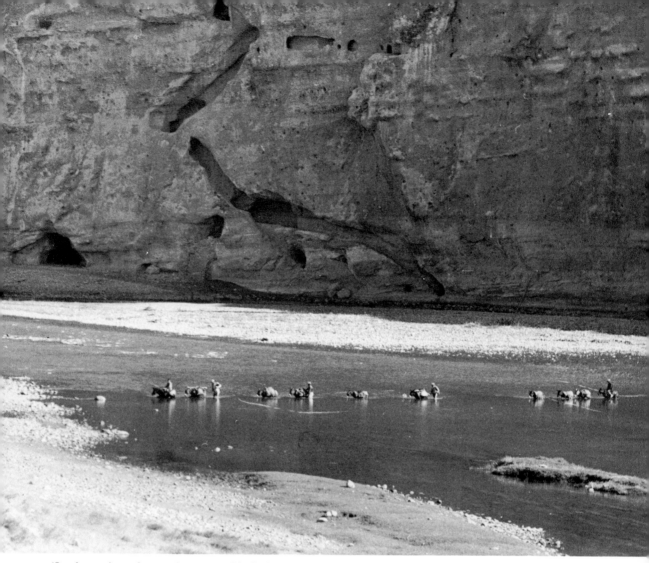

'In the spring of AD 116, presumably before the rising of the Tigris, when laden donkeys can still wade across beneath the cliffs of the gorges, Trajan brought his boats on wagons, for they had been built in such a way that they could be taken apart.' – Tigris gorge, Turkey, 1961.

that overruled military orthodoxy, the capacity to learn from experience, beauty of physique. Not only did he bring the excellence of Greek civilization to Asia; he introduced a revolutionary concept, the universal brotherhood of Man. The Hellenistic ideal corresponded to what Freya believed to be the best in the British Empire – open frontiers, free trade, religious tolerance, respect for differences of custom. It had been the failure of the British to live up to these ideals, she believed, their frequent clubbishness and insensitivity towards subject peoples, their disastrous record on education, that caused the Empire to collapse in a welter of empty nationalist slogans. Similarly, on a personal level, Alexander's leadership corresponded to the aristocratic, public-school virtues

she most admired. Invariably courteous and generous, he always marched with his men: 'It was easy in our own slow travel', she wrote, 'to picture the comradeship the day's march produces, with stray discomforts and sudden good moments of shade or water, or the scent of honeysuckle blown across the track, or to think of how the King's sayings were handed from mouth to mouth along the column, while he walked under the broad shallow hat of the Macedonian fashion at its head. The boyhood friendships continued through these marches lasted him all his life . . .' Like General Wavell, Alexander was subject to fits of generosity. Wavell, in the desert mess tent, would order a double scotch which he would leave untouched for the mess stewards, so they could enjoy a drink which only an officer could order. Alexander, seeing a man stumbling under the weight of gold booty, told him he could keep it if he reached his tent with it. Even in his lifetime Alexander was deified, producing a cult which, as with the later Roman emperors, became a focus of allegiance for the subject peoples. Years after writing *Alexander's Path* she confided to Paul Scott – not entirely facetiously – that she had thought British rule in India could have been saved by the deification of the Viceroy (who happened at the time to be Lord Wavell).

'We came here to the tents of Central Asia, the *yurts* with round roofs and painted screens. This particular camp was poor and untidily perched down a slope, and looked as if some wind had tossed it there, as fragile as foam on the breast of a wave.' – Yurts, Afghanistan, 1968.

'When the Turkish ancestors came down from the steppes of Mongolia, there was no personal malice, merely a necessity for the grazing of innumerable flocks. The civilizations of Central Asia went down before them and have not yet recovered, and so the cities vanished, never to return.' – Road to Ghazni, Afghanistan, 1968.

After Alexander, an exploration of the Roman frontiers in Asia was the inevitable next step. For, following a brief intervening trip to Lake Van (recorded in *Riding to the Tigris*), Freya had decided that she was now getting too old to travel unaccompanied, and would continue to concentrate on history. In contrast to the Greeks, she found the Romans brutal and unimaginative. 'I have started chapter one of the Romans,' she told Christopher Scaife in 1962, 'the miserable tearing up of the Middle East by those brutal Fascists. I must try to find a few nice ones to keep me going, Pliny so boring, Cicero insufferable, Julian, I discover on reading his letters, an appalling prig. Even Catullus jeers at a man for *being poor!*' Her lack of rapport with the Romans accounts, no doubt, for the somewhat dense and unleavened quality of *Rome on the Euphrates*, her last major work. She neither liked nor approved of the Roman policy in Asia: whereas Alexander's successors, the Seleucids, had 'kept the passage into farther Asia open as a bridge' for trade, the Romans closed it as a frontier,

Above: 'A great Abbasid bridge, the sort of bridge one thinks of only in the backgrounds of primitive painters ... It is moving to see the Byzantine body of the huge walls and then the top all Saracen: how much bloodshed in a little architectural detail of that sort!' – Abbasid bridge over the Batman Su, Turkey, 1961.

Below: 'The wide cornlands with Kiahta stream meandering through them swept like an avenue to feed the garrisons ... and are still crossed by the bridge and the road rebuilt by Severus. But where the columned bridge of Kiahta led to is a mystery.' – Roman bridge, near Kiahta, Turkey, 1962.

'This morning I went to Ctesiphon – a cold, clear desert day with the sun bright over a yellow earth and the low far cliffs and little tiny knolls and creases of the earth all caught up into a blue sky by the mirage. We saw the arch getting bigger and bigger and more lovely as we drew near till we could come close enough to see it in all its majestic desolation.' – Arch of Ctesiphon near Baghdad, *c.* 1957.

ending, for the next 2000 years, Alexander's dream of uniting the world. Her ability to conjure up a sense of landscape in history remained unimpaired: she saw the lie of the land with a general's eye, she heard the clatter of spears with a novelist's ear as she relived ancient battles between the Romans and their Parthian and Scythian enemies. But *Rome on the Euphrates*, like most of her later books, is an account of the past rather than a record of the traveller's encounter with the present and its everyday people. With the author no longer so eager to please, more insulated by age, affluence and the presence of European companions from her human surroundings, these are less travel books then meditations on history discovered through landscape. And just as the visitor to an ancient site may have to trudge miles, footsore and sweating through shadeless scrub and ankle-twisting masonry before coming across a finely-wrought sarcophagus or exquisitely-carved capital, so the reader of these books finds the nuggets widely-dispersed. They are not for the lazy or faint-hearted.

·5·
A VISION OF MOUNTAINS

'ONE LIFE is an absurdly small allowance,' Freya had once written to a friend when she was 36. In fact, Providence has been kind to her, allowing her to live well into her nineties, to enjoy to the full the celebrity her travels and writings have brought her. In 1953, Coronation Year, she was awarded the CBE, a comparatively rare distinction for writers. In 1972 she became a Dame, the somewhat oddly named female equivalent of a knight. She lunched, more than once, with the Queen at Buckingham Palace; and twice she was invited to stay with one of her fans, the Queen Mother, at the Castle of Mey in Scotland. Of course, she also experienced the loneliness of surviving when most of her

Opposite: 'Perhaps the love of hills came in years before memory when I was carried about the Dolomites for it seems to have been there spontaneously and always; every new mountain still comes to me with a sort of ecstasy.' – Nepal, 1970.

Above: 'Perhaps the sight of a long road winding, the sound of horses' hooves or the wayside stream will persuade the traveller to try just one more journey before the pleasant world comes to an end.' – Freya in the Himalayas, aged 87, 1980.

'The most remote place I have ever been to: it makes me realize how much more the Middle East is still our own Hellenistic world ... Here it is like a window opening onto something as rich and strange as the Tempest poem.' – Forbidden City, Peking, 1961.

generation had passed on. But Freya has never been one to mope, or live nostalgically in the past. She continued her travels well into her eighties. In 1961 she flew to the Far East. She was able to visit the great Cambodian temples of Angkor Wat before they became part of a battlefield. 'No Gothic cathedral,' she wrote, 'none of our monuments was ever more noble than this central creation ... The serene, mounting to a climax, was never better felt in any place of worship.' The same journey landed her in Peking, where Michael Stewart had now become chargé d'affaires. China, she told Jock, was 'the most remote place I have ever been to: it makes one realize how much the Middle

Opposite: 'The walnuts and oaks and orchards where the Ming tombs stand in a great semicircle, each in a landscape and solitude of its own. The most lovely are those half-ruined and not yet repaired, with their altars darkened with lichens and the stone vessels overturned. And always some flat-topped pine to soften the outline and lovely roofs of temples and pagodas.' – North Gate, Forbidden City, Peking, 1961.

'The people are nice. As soon as you smile they smile back and even their poorest clothes ... have a natural elegance, as like the Parisian in an Oriental way as is their delicious food.' – China, 1961

Opposite above: 'It is so beautiful, the curving shallow beaches and retreating bays, the blue distances of peninsulas and islands, the domestic look of the smooth waters with sampans or junks dusky and slow, built out of the vast planks of the forest trees.' – Hong Kong, 1961.

Opposite below: 'We had two days of eight hours in a jeep, and a day in between of pagodas gone mad ... mostly that Burmese fancy which look like the apotheosis of a turnip.' – Burma, 1961.

East is still our own Hellenistic world'. And it was with a certain relief that she left 'loaded with Sung Ming and Ching pottery and jade and a few little bits of Ming tombs collected on the road'. 'It has been a wonderful month,' she concluded, 'and I feel that something essential to a knowledge of the modern world has added itself to my store. But I never want to live for long behind an iron curtain.' Freya was also fortunate in getting to Afghanistan before it, too, became a battlefield, when the 'peace and harmony of earth and men' she found there would be shattered by Soviet gunships and Mujahiddin rockets ... In 1968, with three young English friends, she made a trip by Land-Rover to find the Minaret of Djam, an architectural masterpiece deep in the almost impassable mountains between Herat and Kabul. 'The minaret stands alone and perfect,' she wrote in the last of her travel books, 'with no other building near it ... Its whole surface from top to bottom is covered with rectangles, lozenges, stars, knots and fancies of deep-cut tracery in the hard-baked earth which the Islamic art of the eleventh and twelfth centuries knew how to handle to such purpose ...'

Freya also went to Soviet Central Asia, visiting the turquoise domes of Samarkand, where the Soviet efforts at restoration impressed her, as did their social and cultural policies. 'It seems to me that the Russians are being very wise down here,' she told Jock, 'interweaving East-West generally, so that the people adopt the new ways not only without shock but with enthusiasm.' In 1970 she fulfilled a life-long ambition by visiting the Himalayas for the first time. She was accompanied by Mark Lennox-Boyd, the grandson of Lord Iveagh, an old family friend who had had a villa in Asolo. She rode a pony which took her up to about ten thousand feet. 'Every day more beautiful, different and dangerous,' she told Colin Thubron, a new friend and fellow travel-writer. 'So it should be, and in fact *is*, life and death so very near together, one doesn't quite know which is which.' In 1976, greatly saddened by the death of one of her closest friends, Dulcie Deukar, she revisited Yemen for the first time in nearly forty years. 'So glad to see it all again,' she wrote ecstatically, 'and apart from too many cars, not really different. The tall stone houses and their white-painted windows are clustered just the same, and the crowd more friendly than in 1940.' 'I can no longer do much,' she confided to Anita Forer, a Swiss admirer who, outraged at the news that Freya had had to travel in other people's vehicles, had presented her with a fully-equipped camping car, 'but am taken by car, sometimes on, sometimes off the new roads

Opposite: 'Only the minarets remain, four crooked fingers not unlike factory chimneys in the bareness of their surroundings, yet melting, pale turquoise and white mosaic, into the heaven they belong to.' – Herat, Afghanistan, 1968.

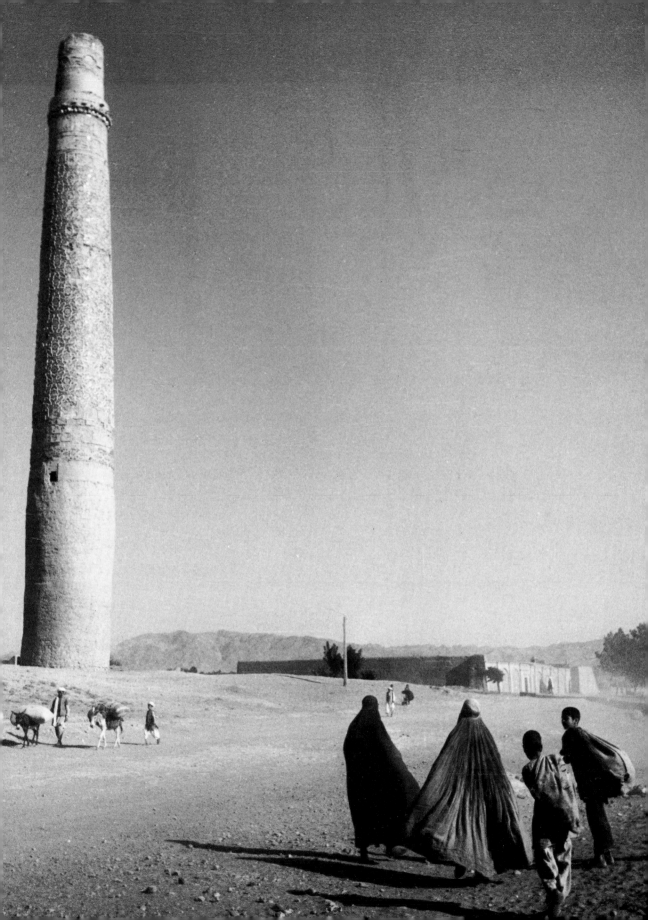

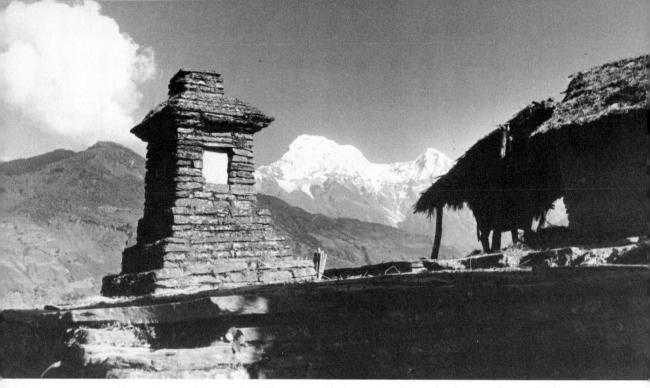

Above: 'I can still scarcely believe that this is true, and not the dream of a good many years still going on. It is just *romance*, all the things Keats and Coleridge saw in their visions, here part of everyday with the patches of squalor left out by them but very pleasant.' – Nepal, 1970.

Below: 'This is a true feeling, presenting humanity as it is, amid the antiquity, the size and the grandeur of earth. It is worth a long, hard journey to attain it, for it is scarcely to be found in towns or easy places, where men triumph so habitually one over the other.' – Nepal, 1970.

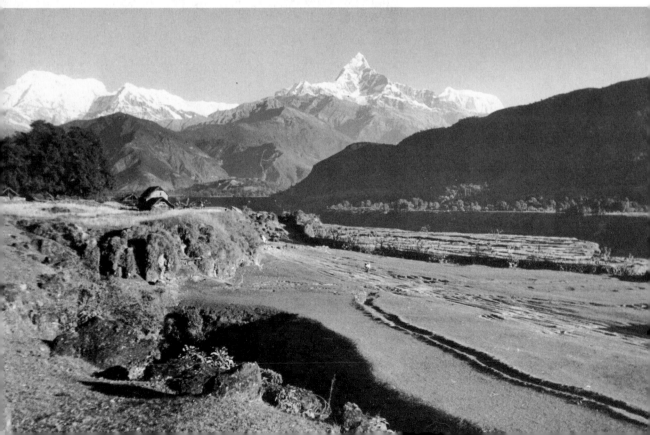

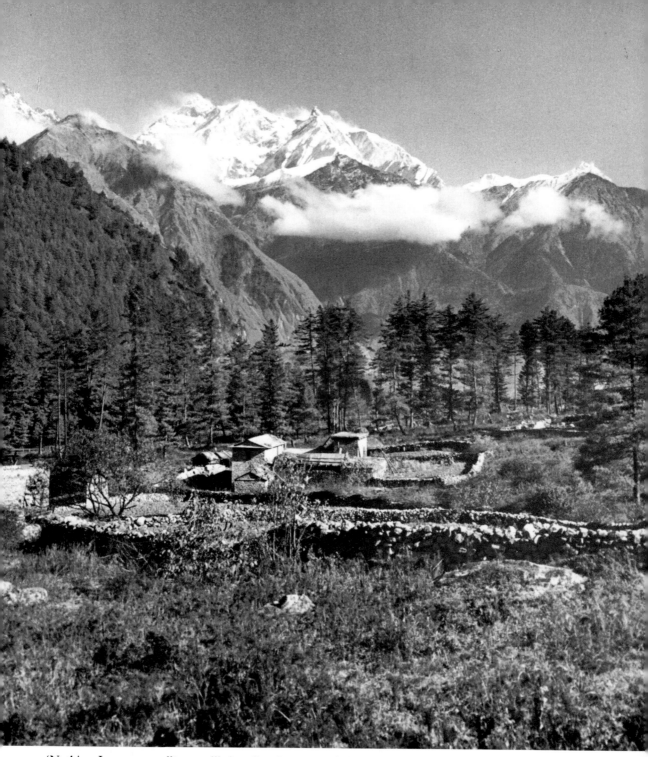

'Nothing I can ever tell you will describe the awe and the majesty of this approach, the last terrestrial footsteps to infinity. The three visible peaks of Annapurna are melting in their snow into the sky, the shoulders of the great brown hills support them, and then the rounder curves and spearheads of the pines.' – Nepal, 1970.

(Chinese) to look at the hills beyond hills, the blue ridges behind their long sandstone cliffs that look as if Titans had laid them down in long terraces of stone ... I have only been out twice for any distance, and sit in the lovely garden with its old earth walls and two or three of the beautiful earth houses in sight around it, and try to read my Koran.' The following year, now aged 83, she took up a new career as a television star. The BBC filmed her, discoursing about Life, History and Art, with Mark and Arabella Lennox-Boyd, on a barge drifting down the Euphrates. The first night the raft inconveniently became waterlogged, and the party had to decamp to a hotel. But they managed to get it afloat again, and the expedition proved a success, not least because for the first time, it brought Freya before a mass audience. Her books, reprinted in paperback, began to reach a wider readership than before.

A second film had Freya back on her pony up in the Himalayas, where she made her last serious expedition early in 1980. Now 87, she was somewhat apprehensive. 'Will all this turn out well?' she asked her old friend, Sybil Cholmondeley. 'I have no idea but am, like you, unwilling to let old age interfere too much. After all, we have had the capital of life in our hands, and if it ceases to give interest, there is no cause to grumble.' Despite the expense and discomfort, the trip, organized by Dick Waller, a family friend from Dartmoor days who specialized in exotic safaris, was an unqualified success. 'Nothing mattered when one was back in the mountains, their dazzling teeth edges in the sun,' she wrote afterwards to Teddy Hodgkin, a colleague during the war who had become a neighbour in Asolo. 'I can't tell you what a joy it was to reach the great bastions, like the outworks of some immense fortification and see the shining edges like swords in the sun. We got as far as the pinewoods of Annapurna, riding and walking through them, but the pass over the north side was blocked – two days in a room kindly lent in the last village (WC down nineteen steps smoothly sheeted in ice).' She recovered from this exertion in Indonesia, visiting Java, Sumatra and Bali before returning to Asolo.

Thereafter Freya's journeys became less arduous and expensive. There were visits to Turkey and Greece, trips to the Dolomites and, in her 93rd year, she was planning a journey to Spain with Michael Stewart. Ironically, in old age she was free from the financial difficulties that had faced her throughout her more active life. Frustrated by lack of money for travel, she had sold the Casa Freia to the provincial government in 1966, having already built herself a fine, but rather too large, villa on a hill a few miles from Asolo. This inevitably proved too expensive, but she eventually sold it for a good price, which she invested prudently. She settled finally in a comfortable flat in Asolo with a charming terrace overlooking the little valley, with its orchards and vines, that leads on to the Venetian plain. Here, as she became older and more infirm she

was looked after by the faithful Caroly Plaser and two devoted cousins from Bari, Anna and Giovanna, who watched over her, day and night.

In May 1985 the Municipality of Asolo once more decided to honour Freya (and itself) by presenting her with the keys to the city. In a touching ceremony attended by her closest friends and admirers from England and Italy, she sat

'... the security of home, the sweetest and oldest sensation round which the human vine can wrap its tendrils'. – Band of the Household Cavalry (Blues and Royals) at the presentation of the Keys of Asolo to Freya Stark, May 1985.

on the platform erected in the little piazza. With the delighted expression of a child enjoying a birthday treat, she heard the mayor, the provincial governor and other dignitaries make elaborate speeches comparing her with Shakespeare and Queen Cornaro, while the band of the Household Cavalry, specially brought from Germany at the expense of a local bank, serenaded her with 'Rule Britannia', the triumphal march from *Aida*, and other appropriate Anglo-Italian tunes.

The festivities ended with a banquet in her honour. Freya sat resplendent in one of her eastern costumes with her great-nephew Paolo and his wife, while the local bourgeoisie, its wives, its friends, its relatives and hangers-on, feasted on salmon and roast suckling-pig. The years of strife, both in her family, and between the nations of her birth and her adoption, were at last forgotten.

* * *

Any verdict on Freya Stark's work as a writer must wait until a future generation, free from the cross-currents and passions of the post-colonial age, can make a detached assessment. It is as a personality, a 'force of nature' as someone once called it, that those of us who were fortunate enough to know her will always remember her. Her life, like her journeys, consists almost equally of triumphs over obstacles, and of making the best of her advantages. She was born a plain girl into a glamorous family; in childhood she suffered a physical trauma that scarred her for life, social isolation and – as her parents' marriage broke down – emotional deprivation. She not only rose above these disabilities: she turned them to positive advantage. In childhood she taught herself to read in more languages than most of us can order a drink in. Her domestic unhappiness opened her eyes to the new world of the East; her loneliness, from which

'Like looking through a window on a life completely unknown and strange and beautiful from its fitness: an immense sense, too, of space and freedom.' – Bedouin tent in Syria, 1939.

'... in three years time I could learn enough Persian, Turkish, Kurdish and Arabic to get about, and I believe I would be the only Englishwoman in the Near East to do so; and then something amusing is bound to turn up.'

Above: Pamela Hore-Ruthven, Gerald de Gaury and Stewart Perowne – Venice, 1947.

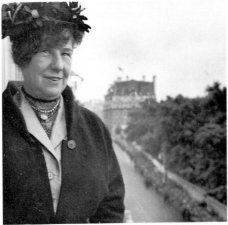

Above: At the coronation of Elizabeth II – Piccadilly, 1953.

Right: With the Queen Mother – Castle of Mey, Scotland, 1975.

Freya with her dog Zeno – 1964.

she suffered all her life, drove her to make personal relationships, first with the people among whom she travelled, and later among the ever-widening circle of friends and admirers she acquired in the course of her work in the Second World War.

Freya's way with people enabled her to make the best of the opportunities that came her way. She charmed her passage in – and out – of the Hadhramaut, cajoling tycoons, wheedling governors, holding sayyids or mansabs spellbound with her Arabic, forging a comradely bonhomie with her Bedouin guides. For an unaccompanied woman in a wholly masculine-dominated society, this would have been enough to create a legend if she had not written a word. But she was an artist as well as a traveller. If there was an element of calculation and ruthlessness in her treatment of people – and there were people who, in the course of her long career, felt they had been ill-used by her – this was never from motives of petty selfishness. Artists are like Robin Hood: they may take from the rich who possess wealth, opportunities or knowledge, to distribute their own talents as gifts for the rest of us, to alleviate the humdrum burden of our lives by entertaining us, or opening our minds to perceptions of truth we could never achieve unaided. Most of those, including her wealthier friends who provided her with loans, or gifts, or who otherwise helped in her travels, considered it a privilege, knowing that her egotism was magnanimous, her selfishness disinterested. Those – like myself – with nothing more than time and affection to offer have been lavishly repaid with both.

Freya could be ruthless and demanding, and sometimes a difficult companion. My own experience, travelling up the Central Euphrates with her and Mark Lennox-Boyd in 1962, was not entirely happy. We argued in Aleppo, about Camus's *The Outsider*, which, I thought, she refused to see as being anything more than a tract about criminality. Having been entrusted with buying food for the expedition, I disgraced myself by acquiring large quantities of thirst-inducing anchovies which, knowing little Turkish, I had mistaken for sardines. Yet bruised as I was by finding myself at odds with her in matters both intellectual and administrative, my admiration for her professionalism as a traveller grew as we made our way up the river. Armed with no more than a letter of introduction from the head office of one of the Turkish banks, Freya brandished the document as though it were a firman from the Ottoman Sultan spelling instant dismissal, even death, to anyone who impeded our progress. The hostility of mayors, district governors or policemen dissolved before us; and when we left their protection for wilder Kurdish-speaking areas whose dangers were all the greater because the Turkish authorities mulishly refused to acknowledge the existence of the Kurds or their language, she deftly shifted her ground, and despite her ignorance of Kurdish, charmed the muleteers into becoming our protectors. Arriving at Thilo, a large remote village miles from any motor road where very few Europeans had passed before, she so fascinated our host, the village chief, that he insisted that a grand-daughter, born that very night, be named after her. I wondered how many girls in inaccessible Asian valleys had grown up bearing the improbable name of a Nordic goddess because she had happened to be passing by at the hour of their birth. Freya

Sir Sydney Cockerell – June 1951. Jock Murray – 1954.

was then in her seventieth year and suffering from bronchitis; yet such was her confidence in herself and the confidence she inspired in us, that I never once feared for our safety, even when, crossing the Taurus mountains, we encountered a gale so severe that Mark and I had to pin her to her mule by her short, stubby, redoubtable legs.

Freya's charm, though sometimes manipulative, was far from being confined to the people whose assistance she needed in pursuing her passion for travel. She had a real, and enduring, talent for friendship. Though she sometimes quarrelled with them, her greatest admirers, W. P. Ker, Sydney Cockerell, Bernard Berenson, Jock Murray, Michael Stewart, Dulcie Deukar, and many others, remained friends for life. The size of her correspondence – eight published volumes, with much remaining unpublished, is astonishing, even by the standards of one who grew up before the age of the telephone and who wrote with Victorian gusto. The letters, sharp, spontaneous and witty, with every correspondent addressed individually, as if he or she were the only person that mattered in the world, may well prove her most enduring literary monument.

Why did Freya travel? First, to escape 'into a tolerably peaceful life' as she confided to Stewart Perowne in 1948. 'My mother just *threw* everything on to me and I got so exhausted in parental tangles that the only way to survive was to get away.' But this negative impulse was soon converted into a positive search for truth: 'The true wanderer,' she would write only two years later, 'whose travels are happiness, goes out not to shun, but to seek.' An almost compulsive autodidact, Freya never lost her passion for acquiring fresh knowledge and new skills. In her sixties she began learning Russian, in her eighties

With Bernard Berenson – Asolo, 1955.

With the author – Asolo, 1983.

'... nor did we meet a soul, but rode under clouds that drifted and dissolved ... as if the rock were spinning them as we spin words out of the very stuff we are made of, to vanish and melt in the stillness that produced them.' – Mount Climax, Turkey, 1957.

she went to sketching classes. Throughout her life she read, and re-read the classics; and even in her nineties when memory began to recede, she could recite whole passages of Dante and Shakespeare, Milton and Leopardi. She wrote – she always insisted – not for money, but to convey pleasure and record the truth. To say she wrote for her own pleasure, however, would be wrong; like many of the best writers, she often found the process of composition agonizing and wearisome. But she never saw herself as a professional writer in the modern sense, and tried to arrange her financial affairs so as to be free from dependence on royalties. (She once tried to persuade Jock Murray, her publisher, to convert all her royalties, present and future, into a lump sum for the purchase of a mink coat.)

Writing, like travel, she saw as the pursuit of truth – 'a disinterested wish for direct vision'. The chief ingredient of a good style, she insisted, is 'the sort of truthfulness one tries for in a telegram, to give an unambiguous message in essential words'. Writers rarely achieve success in their own estimations, and Freya was often disappointed with her own efforts. But her claim to being 'disinterested' is fully justified. If she had had more regard for her popularity, for winning more than the *succès d'estime* that her books enjoyed throughout most of her lifetime, she would surely have written lighter, more frivolous works in her later years.

Freya was largely self-taught as a writer. Her style seems to have appeared 'fully armed', like Athena from the head of Zeus. There is little development

of style between her earlier and later books or letters, except for what can be put down to differences in subject matter. Judging from some early stories written in her twenties (not published till 1968 in *The Zodiac Arch*) she could have made an impressive writer of fiction. But she never embarked, self-consciously, on a literary career. She was a traveller turned writer, rather than a writer who uses travel to supply the raw materials of his craft. In this respect, she belongs to the tradition of Kinglake, Burton, Philby and Thesiger, as distinct from Wilfred Blunt and Charles Doughty – literary men who discovered Arabia in order to write about it. But her natural brilliance as a writer placed her – in Sydney Cockerell's opinion – second only to Doughty. At her best, what Freya writes of Doughty can be said of Freya herself; 'No other traveller, I think, makes one share his adventures so vividly, so that the reading has the same quality as though one were journeying oneself.' The similarities are more than matters of subject or style; they share the same vision, at once humane and majestic. In one of her essays, 'Exploring with Words' (1947), Freya quotes, with approval, this passage on Doughty by Ellis Roberts:

'The instinct to imitate, to cloak your own convictions, and to follow alien and perhaps disliked conventions, is based on a deep distrust of human brotherhood. The man who really believes that the distinctions of race, colour, language and creed are ultimately less important than the fact of our common humanity is never afraid to admit the reality and significance of these distinctions: the man who minimizes the reality of the distinctions in the human family is the man who, at bottom, suspects them of having a terribly potent force, a force stronger than that of the brotherhood which is human nature's indefeasible privilege.

Doughty never leaves us with the impression that he is investigating some strange, half-human society; his contact is direct, sincere, instinctive, just because the point of view is remote and separate. He is painting a picture of people like himself who happen to have different habits and a different creed.'

It is Freya's general recognition of social and cultural differences that makes her the opposite of 'Orientalist' in the pejorative sense, winning her admirers on the left as well as the right of the political spectrum. Her vision of empire was not less noble for being impracticable. If she gave due weight to its achievements, she also drew attention to its shortcomings.

Like Doughty, her recognition of non-European values and cultures flowed from the esteem in which she held her own. There were three principal strands in her background – English Tory, Continental cosmopolitan, and Victorian Bohemia, which merged to create an attitude of high-minded cultural élitism. The British lost India, she believed, because they never bothered about education. Similarly, they lost Egypt and eventually the whole Middle East because of 'a lack of clearness and faith in our own values ... We were trying to offer a

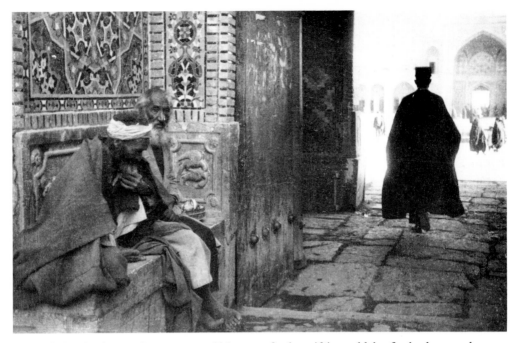

'A revelation is always given to us as if it were *final*, as if it could be final when we human beings know how young we are in our world, with the pattern only just started ...' – Qom, Iran, 1931.

civilization which we did not believe in.' The same had come to be true of England after the First World War, when a complete generation of too 'clever' intellectuals had set about undermining the nation's cultural and social values. In 1943, anticipating the post-war Labour government, she wrote:

'Only one thing seems to be vitally urgent – to make of ourselves *one nation* again, a homogeneous people: I don't think that anyone but the young left-wing people can do it – but they are terribly uneducated! I mean that when I look back on what I have had in life, a constant background of beauty, music, art and the understanding of lovely things: a constant intercourse with people of many different nations and an open doorway into the histories of the past; a sort of *rich* light illuminating everything with a variety of colours – and I look round and see how few people have been so fortunate: and it seems to me that it is just this richness of Civilization which the intelligent young man of the Left needs to make him fit to handle the delicate business of governing, which is after all nothing more or less but the dealing with human souls.'

Apart from the war years, when she threw all her energies into the Allied cause, Freya was not concerned with public activities. She experienced, and conveyed, a deep sympathy for the poverty and ignorance she encountered in the East; but she had no stomach for philanthropy, in which she sometimes

detected the signs of arrogance, born of the desire to extend one's selfhood, to teach rather than to learn. In her religious outlook she never abandoned her inherited Protestantism, despite living in a Catholic country. But beneath any formal religious allegiance there always lay in her mind a profound sense of the unity of being, the transitoriness of mortal life and the expectation of immortality, though not necessarily of the personal kind. Like other true believers, she disliked the divisive rules and regulations with which the different confessions surrounded themselves. Her understanding of religion was intuitive rather than learned. She admired the Arabs as being a people dedicated to non-material values; she read the Quran, but never developed much of an interest in, or any great knowledge of, Islamic theology. She disliked the idea that any revelation could be 'final' (as Muslims believe the Quran to be) 'as if it could be final when we human beings know how young we are in our world, with the pattern only just started and (unless we destroy it all) with the future stretching immeasurably before us'. 'How can one prefer one's miserable singularity', she wrote to Jock Murray in 1956 after a reading of 'Samson Agonistes', 'to that openness of heart which lets the love of God come in ... I think as one gets older, the barriers go on falling to the love of God, the feeling of *oneness* with everything, the certainty that neither death nor sorrow can really matter, nothing can matter but one's own shutting of oneself away from this deep unity – this feeling grows and grows.' The feeling may have been prompted by reading Milton, but its expression is near to Sufism, to the mystical Islamic concept of *fana* or oneness with God. It is a mysticism that is the opposite of asceticism, accepting, not withdrawing from the world.

Perhaps the key to this outlook, or rather to the experience it liberates in a human being, lies in the conquest of fear – the fear of life, with its pains and its dangers and, ultimately, the fear of death. For fear of death is, paradoxically, a fear of living, since life, to be lived to the full, entails the ever-present danger of death. Freya discerned this early in her life, when, climbing a peak in the Dolomites, she missed her footing

'... and dropped into space: the rope held, with an unpleasant jerk round my ribs, and finding itself in the character of a pendulum with a living weight attached, swung slowly out round the bastion of the tower, far, far above the valley and its mountain pastures and white and stony streams ... I felt a slight nausea as I saw my hat revolving in the sunny air on its way down through space; and, into a feeling of panic that was invading me, death suddenly took its place to my surprise; I felt that nothing worse could happen, and that I could take it; and the clutch of fear left as if it were a knot being untied.'

The danger and the vision are One.

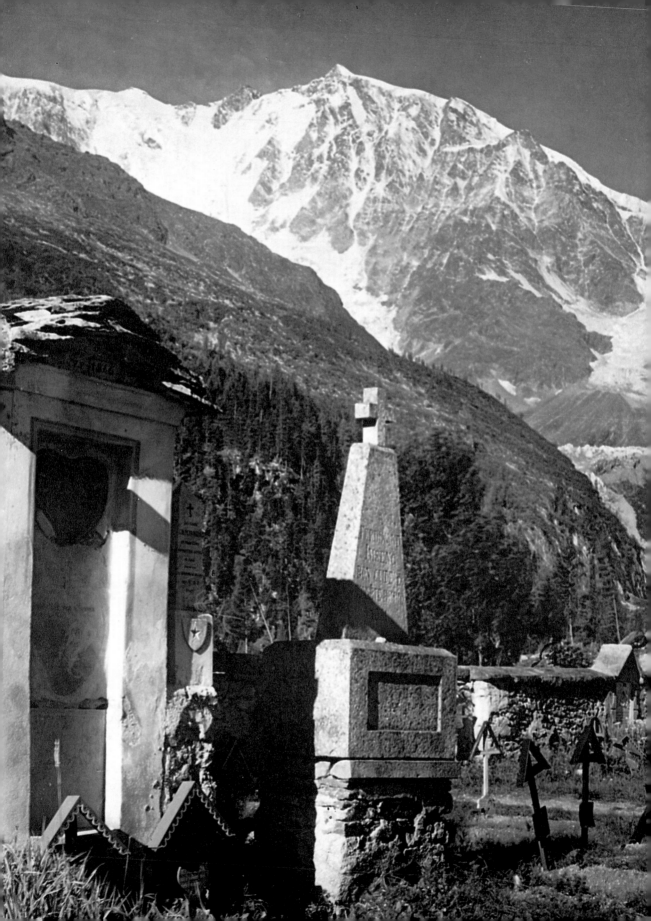

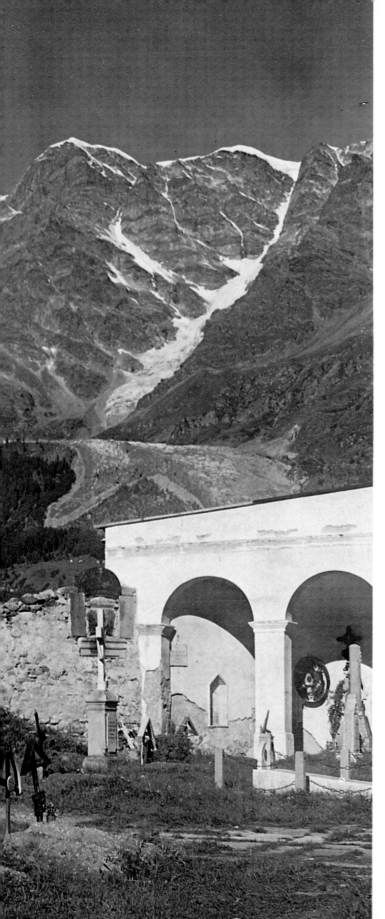

'The best silence is on the summit, when one has achieved it and is resting on whatever space there may be ... It is a hymn of space and sunlight in which sound has become visual and is not heard but seen ... 'How lucky was W. P. to step from this world into the next from a mountain side.' – Macugnaga and the Monte Rosa, near the place where W. P. Ker died in 1923.

ILLUSTRATION ACKNOWLEDGEMENTS

All the illustrations reproduced in this book are from the Freya Stark photographic collection, now housed at St Antony's College, Oxford, with the exception of the following:

Herbert Young (Freya Stark private album): 10, 11, 14, 17, 18, 19, 20, 21, 22, 24, 27 (*left*), 120, 142-3
Freya Stark private album: 13, 15, 16, 22 (*inset*), 27 (*right*), 134, 135, 136
Mark Lennox-Boyd: frontispiece, 121
Keystone Press Agency: 103
Ianthe Ruthven: 131, 137 (*right*)
Joan Hassall: 137 (*left*)